IMAGES
of America

FORT LAUDERDALE
PLAYGROUND OF THE STARS

IMAGES
of America

FORT LAUDERDALE
PLAYGROUND OF THE STARS

Jack Drury

ARCADIA
PUBLISHING

Published by Arcadia Publishing
Charleston, South Carolina

Printed in the United States of America

Library of Congress Catalog Card Number: 2007941603

For all general information contact Arcadia Publishing at:
Telephone 843-853-2070
Fax 843-853-0044
E-mail sales@arcadiapublishing.com
For customer service and orders:
Toll-Free 1-888-313-2665

Visit us on the Internet at www.arcadiapublishing.com

This book and my experiences with many celebrities could not have happened if I had not moved to Fort Lauderdale with my family in August 1960. This fantastic city with all its attributes and activities attracted celebrities, and I seized those opportunities to not only make friends but to also turn them into business relationships.

The public relations firm I worked for in New York City, Bell and Stanton, had an important client headquartered in Fort Lauderdale by the name of the Gill Hotels. In order to keep hotel owner Bob Gill happy, Alan Bell, president of the firm, moved me and my family of four to Fort Lauderdale—so thank you, Alan and Bob.

Due to over-expansion by Bell and Stanton, the firm closed the Florida office, so in 1962, Jack Drury and Associates was born. The time I spent building my new business, plus my involvement with many celebrities, resulted in a large amount of time spent traveling away from home; therefore, I dedicate this book to my wife of 55 years, Marie, my four children, John, Chris, Sue, and Linda, and my nine grandchildren. I am glad to have a chance to show my family where I was all that time.

Finally, I give all the honor and glory for any success I might have been blessed with to my Lord and Savior, Jesus Christ.

CONTENTS

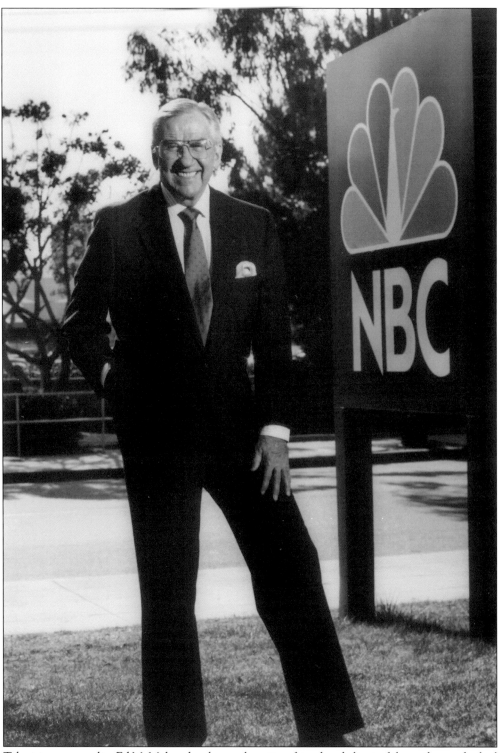

Television personality Ed McMahon has been a longtime friend and client of the author and asked to write the foreword to this book. Please see his comments on page 7. (Courtesy of NBC.)

FOREWORD

I met Jack Drury in 1962 when he convinced Johnny and I, and our staff, to come to Ft. Lauderdale to plan the format for the new Tonight Show starring Johnny Carson. We instantly became close friends and I recognized immediately that he had the unique ability of creating opportunities for celebrities like myself. He called it "Seizing Opportunities".

I watched with amazement how he came up with idea after idea to put money in my pocket, being careful to avoid any conflict with my NBC obligations. He is still doing that today.

Even though he lived in Ft. Lauderdale, Florida, a long way from the center of show biz, he became a close confidant to my boss, Johnny Carson. He was one of the few non show biz people that Johnny spent time with. Jack convinced Johnny to invest a new Florida city called Coral Springs before anyone ever thought of living there. It was one of Johnny's most profitable investments. Bob Hope was in Jack's sights and after he met Bob at my golf tournament in the Quad Cities, he seized that opportunity and worked with this legend on eight of his NBC-TV shows. Being a golfer did not hurt his friendship with Hope, who was a golf fanatic.

Blind singer/entertainer Tony Sullivan, tennis great Billie Jean King, and even her famous opponent Bobby Riggs became friends of Jack.

When he met Buffalo Bob Smith, the creator of the number one children's show -- Howdy Doody, the show had been off the air for 10 years. What did Jack do but arrange for financing and put the New Howdy Doody Show back on television.

Football stars Joe Namath and Johnny Unitas, baseball's Maris, Mantle and Whitey Ford all benefited from Jack's creative talents and to me, one of the most amazing friendships he developed was super star, Cary Grant.

Well, enjoy this book about how these celebrities put Ft. Lauderdale on the front pages of America.

Ed McMahon

ACKNOWLEDGMENTS

I want to thank my family and friends who, for many years, got tired of hearing all my stories about my celebrity friends and pushed me to do a book. I think they did that to shut me up. When Arcadia Publishing and I made an agreement to do this book, I went into my files and gathered up all the photographs that have been sitting there all these years, and you are holding the end result. This is a pictorial history of these unique, talented people who, through their achievements and talents, became what is called a "celebrity." They got that title whether they liked it or not.

This book covers only those celebrities that I was involved with personally. There were many more that were a part of the history of Fort Lauderdale. Because most of the images are from my personal collection, I naturally appear in many photographs and will be identified as "author."

I want to acknowledge my talented son John, who assumed the responsibility of scanning and processing all the images in this book—thank you, my son, you are the best.

Finally, this book is a tribute to my celebrity friends who made my life exciting but will not enjoy this tribute to them because they are no longer with us, namely: Johnny Carson, Bob Hope, Jayne Mansfield, Mickey Hargitay, Mickey Mantle, Roger Maris, Cary Grant, Bobby Riggs, Julius Boros, and one of my closest pals, "Buffalo Bob" Smith.

All images, unless otherwise stated, are courtesy of the author.

One

NEW YORK YANKEES

The 1961 World Series champions, the New York Yankees, moved their spring training camp from Tampa to Fort Lauderdale in 1962, and residents and tourists could see roaming throughout this small town the likes of Joe DiMaggio, Mickey Mantle, Roger Maris, Whitey Ford, Yogi Berra, and many more. It was exciting for both baseball fans and the general public. No matter who you were or where you lived, you knew about the Yankees; they were definitely celebrities in every sense of the word.

Hotelier George "Bob" Gill, who was a friend of the Yankees owner, Dan Topping Sr., was the man most responsible for the champs' decision to move to Fort Lauderdale and train in a new stadium built by the city (next to Lockhart Stadium). It was aptly called Little Yankee Stadium. That stadium is where the Baltimore Orioles train today.

In 1961, Roger Maris broke the home-run record of Babe Ruth, hitting 61 balls out of the park. Mickey Mantle hit 54 home runs of his own that year. These feats, plus the Yankees winning another World Series championship, attracted every major sports writer from not only this country, but also from around the world to cover spring training. All during spring training, stories were being sent to the national media with a Fort Lauderdale dateline. No hired public relations genius in the nation could produce such positive stories about the city.

Tourists booked their vacations around spring training, and, of course, the team and the sports writers all stayed in local hotel rooms, so the town witnessed a deluge of dollars, all because of the vision of city leaders and, most of all, Bob Gill.

Now, in 2007, the results of the Yankees' decision to move to Fort Lauderdale are still visible. Joe DiMaggio's name is on a children's hospital; Whitey Ford and his wife, Joan, live in town; and some of the Yankees still visit Fort Lauderdale on vacation.

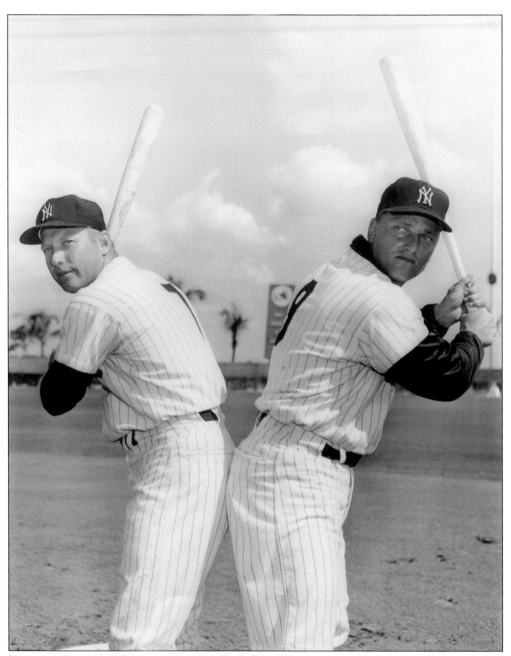

Known as the "M&M Boys," Mickey Mantle (left) and Roger Maris, shown here in 1962, provided the home-run power to the 1961 World Series champion New York Yankees. In 1961, Mantle hit 54 home runs before taking sick, and Maris broke Babe Ruth's record of 60 home runs by hitting the record-breaking ball on October 1, 1961, in the last game of the season, against the Boston Red Sox. Maris was Major League Player of the Year in 1961 and ended his career with the St. Louis Cardinals in 1968. Maris and Dale Murphy are the only two-time MVPs who are not in the Baseball Hall of Fame. (Courtesy New York Yankees.)

Many agree that Edward Charles Ford, better known as "Whitey," was the greatest left-handed pitcher in Yankee history. Whitey Ford (left) is shown in the photograph at right with the author at Coral Ridge Country Club in 1975. Ford was with the New York Yankees for 12 seasons, and his catcher for most of that time was Yogi Berra, who said Ford was not only a thinking man's pitcher, but also a great competitor. Mickey Mantle hit 536 home runs in his 17 seasons with the Yankees. He used that same powerful swing on many golf courses in Fort Lauderdale. The bottom photograph is one of Mantle hitting a long iron during a tournament at Coral Ridge Country Club in 1967. Mantle retired from the Yankees in 1968 after spending his entire 18-year career with the team and was inducted into the Baseball Hall of Fame in 1974.

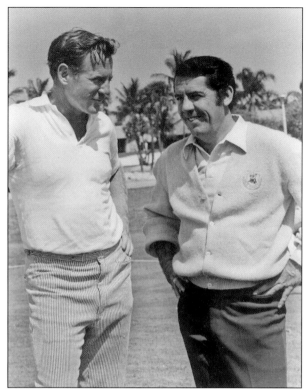

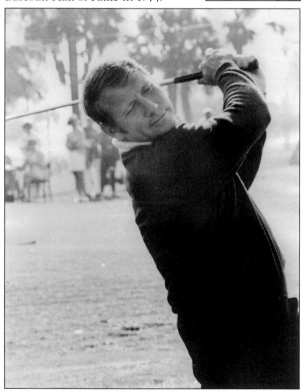

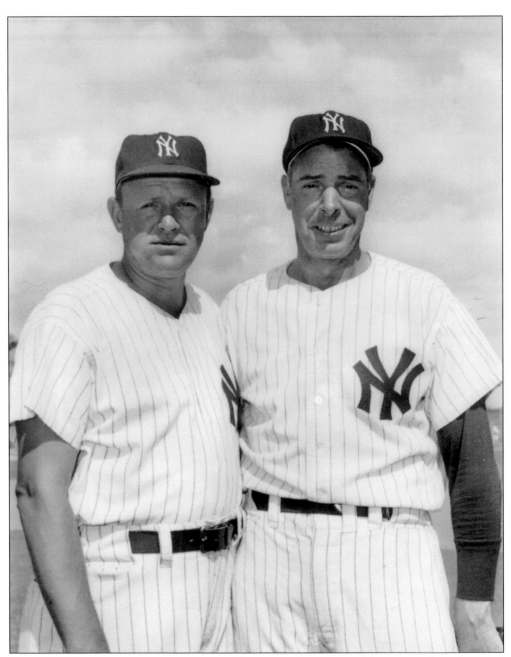

In 1964, Ralph Houk (on the left) was named the general manager of the New York Yankees and liked Florida so much that he later made Pompano Beach his home. While retired from baseball, Joe DiMaggio was part of the coaching staff in those years. DiMaggio, who was married to Marilyn Monroe for 274 days in 1954, invited Monroe to visit him during spring training in February 1961, and the author picked her up at the airport and brought her to the Yankee Clipper Hotel. That was the last times Joe saw her; she died in August 1962. (Courtesy News York Yankees.)

To help promote the Fort Lauderdale beaches, Yankees super-star shortstop Phil Rizzuto agreed in 1965 to put on a bathing suit and pose for this publicity shot. The above photograph includes three of the author's children, who volunteered to be models (for free, of course). Chris Drury was pitching, John Drury was catching, and Sue Drury acted as the umpire. In the bottom photograph, Sue Drury called "strike three—you're out" on Rizzuto, known affectionately as "the Scooter." Pitcher Chris Drury and his brother John Drury agreed with their sister, but not Phil, who was considered one of the great shortstops in baseball.

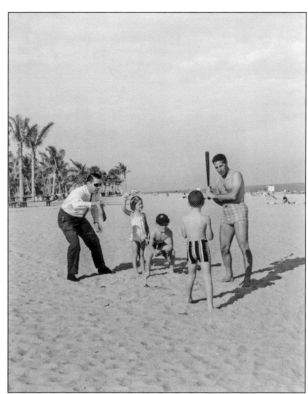

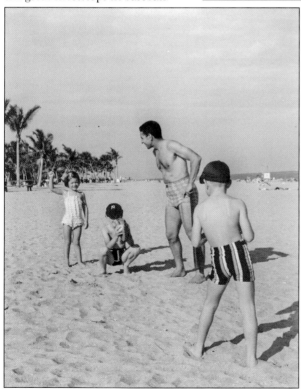

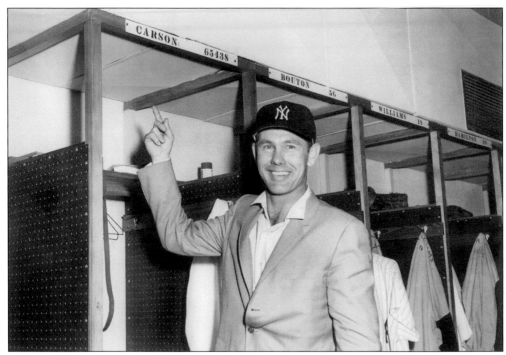

In 1963, Johnny Carson, the host of NBC's top-rated *Tonight Show*, one of the most profitable shows ever on that network, traveled to Fort Lauderdale with his three sons, Chris, Rick, and Cory, to throw out the first pitch of the first game of spring training for the Yankees. The photograph above is Johnny Carson after the game in the Yankees' locker room, where the team thanked him by providing a uniform and a locker as a practical joke. Spending years in Fort Lauderdale with the New York Yankees during spring training, Whitey Ford made Fort Lauderdale his permanent residence by buying an apartment on the Galt Ocean Mile and often helped many local charities. The bottom photograph is of Ken Behring, the founder of the Wheelchair Foundation (left), Ford (center), and local businessman Randy Avon at a fund-raiser in 2004. (Below courtesy of Barbara McCormick.)

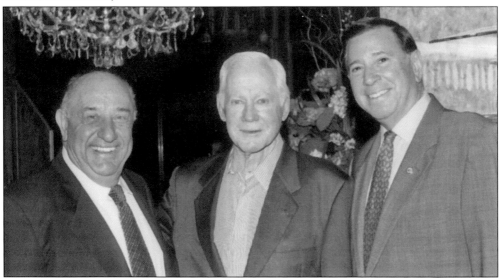

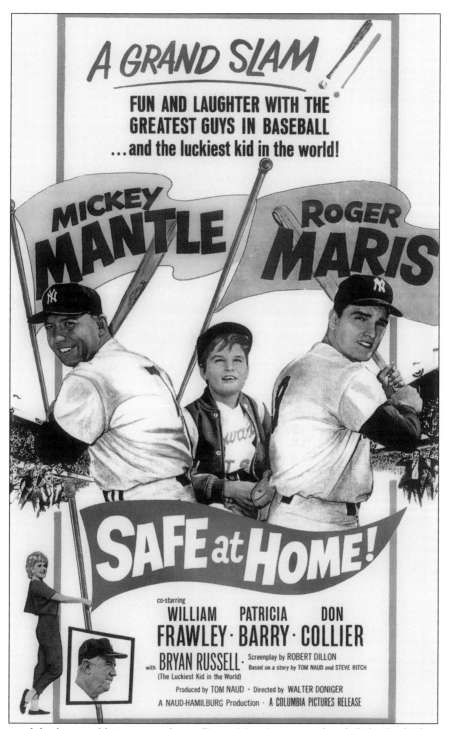

Because of the huge publicity created over Roger Maris's quest to break Babe Ruth's home-run record during the 1961 season, Hollywood took notice and decided to do a movie called *Safe at Home!* featuring Maris and Mickey Mantle. In 1962, the author arranged for the film crew to stay at the Trade Winds Hotel during the filming.

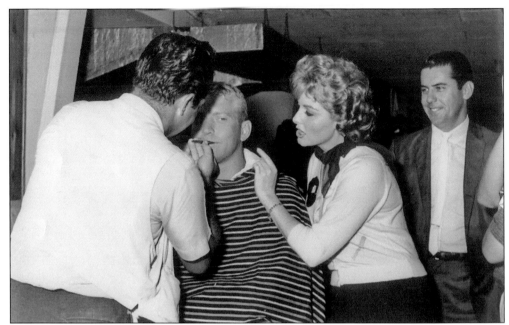

Mickey Mantle, who played for the New York Yankees from 1951 to 1968, hit 266 home runs in Yankee Stadium during his career—seven more than Babe Ruth. Patricia Barry, the female lead in the movie *Safe at Home!*, is shown in the photograph above with Mantle as he gets made-up for the next scene. William Frawley, who made hundreds of movies, was best known for his television career as Fred Mertz on the *I Love Lucy* television show, which featured Lucille Ball. Frawley was a rabid Yankees fan; therefore, the producer selected him to play the general manger in the movie. In the bottom photograph, Frawley is joined by a child actor, Bryan Russell, and headliners Maris (right) and Mantle (second from left) at a location near the stadium in 1962.

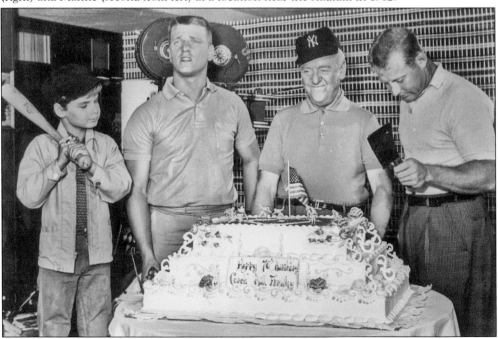

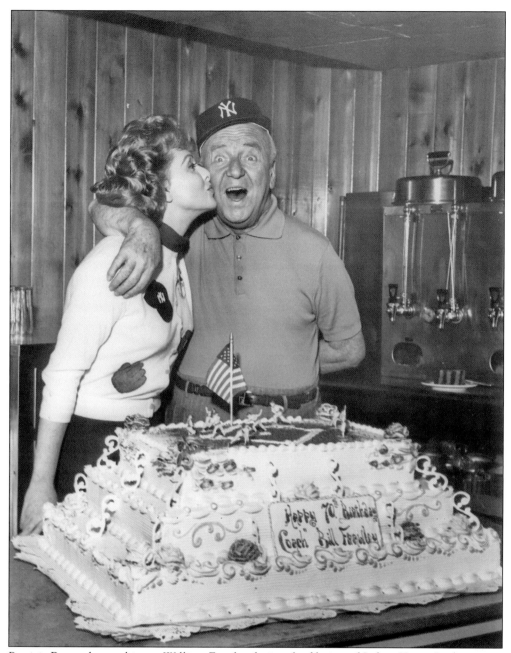

Patricia Barry plants a kiss on William Frawley during the filming of *Safe at Home!* In the movie, Frawley celebrated his 70th birthday, but he was really 75. This would be the last feature film Frawley ever made.

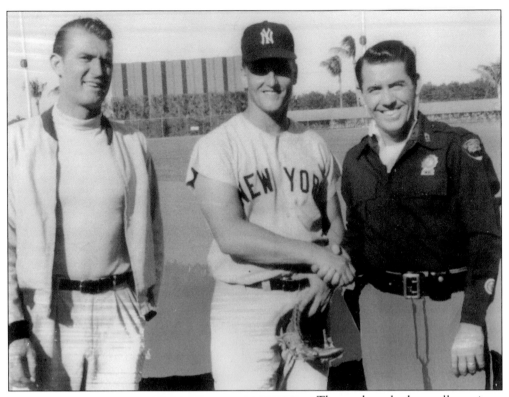

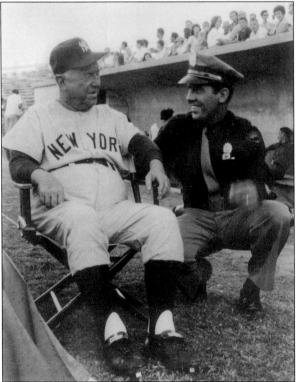

The producer had a small part in the film for a local policeman and asked the author to play the part, which had only two lines and less than a minute on the screen. The photograph above is the lead male in the film, Don Collier (left), with Roger Maris and the author. The photograph at left was taken as William Frawley takes a rest in between scenes during the filming in 1962. He loved the New York Yankees so much that his contract with *I Love Lucy* stated he did not have to work during the days the Yankees played in the World Series.

On their day off from playing baseball and filming, Yankees stars Mickey Mantle (second from left) and Roger Maris (third from the right) spend time with friends, including Notre Dame and Green Bay Packers football star Paul Hornung (center) and actress Patricia Barry (far right). Besides the author, hidden behind Barry, the others are unidentified.

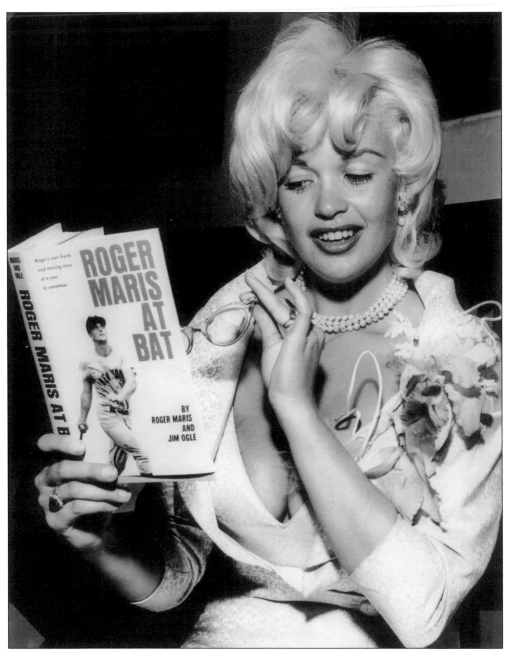

One of the leading blonde sex symbols of her time, Jayne Mansfield was a big fan of the New York Yankees. Shown here in March 1962, she poses for a publicity photograph to promote a book entitled *Roger Maris at Bat*. This was taken prior to her flight to Orlando to appear at the Orlando-Seminole Jai-Alai.

Two

JOHNNY CARSON
AND ED MCMAHON

In July 1962, it was common knowledge that Johnny Carson was replacing Jack Paar as the host of the popular *Tonight Show*. Carson was a young, up-and-coming comedian, but few people knew him. He became the host of NBC's *Tonight Show* in October 1962 at the age of 36.

Carson, his writers, director, producer, and his side-kick, Ed McMahon, were planning to go to Miami in August to get away and create new ideas for the show, but the author persuaded them to come to Fort Lauderdale since it was smaller and less hectic, and Carson was known to be shy and uncomfortable around large groups of people.

The result of those 10 days in August 1962 was a 30-year friendship between Carson, McMahon, Fort Lauderdale, and the author. They came here so often that Carson kept a suite at the Ocean Manor Hotel on the Galt Ocean Mile. (Former Fort Lauderdale mayor Cy Young owned the hotel at that time.) McMahon spent much of his vacation time at the Lago Mar Hotel, a guest of hotel owner Sid Banks (Walter Banks, who was a little boy running around the pool at that time, is now the boss at that great resort).

Carson and McMahon mentioned on the air their many trips to Fort Lauderdale, which let millions of people know about the city. One of their favorite stops every visit was the world-famous Mai Kai Restaurant, and the "Mystery Girl" from the Mai Kai delivered the mystery drink twice to Carson on the show. He told his viewing audience he ordered a drink "to go."

James S. Hunt of Coral Ridge Properties, the developer of the Galt Ocean Mile, bought 10,000 acres in the mid-1960s and planned to build a city called Coral Springs. Carson made an appearance at the opening ceremony in 1964 and even bought 60 acres as an investment. This turned out to be one of the most profitable investments Carson ever made in his entire life.

Carson's show accounted for 17 percent of the profits of NBC and lasted for 30 years. After 4,531 shows, he called it quits on May 22, 1992, and went into total retirement. He died quietly with his family by his side on January 23, 2005.

McMahon still visits Fort Lauderdale frequently and was given the honor of being the grand marshal of the biggest event in Fort Lauderdale, the Winterfest Boat Parade, in 1992.

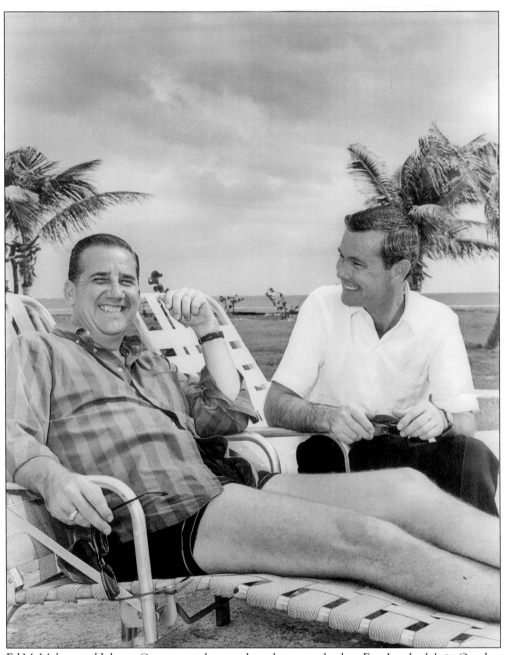

Ed McMahon and Johnny Carson were happy when they came back to Fort Lauderdale in October 1963 to celebrate their first anniversary of the *Tonight Show* on vacation while at the Lago Mar Hotel. The format for the new show, hosted by Carson, was literally born here in Fort Lauderdale in August 1962. (Courtesy Roy Erickson.)

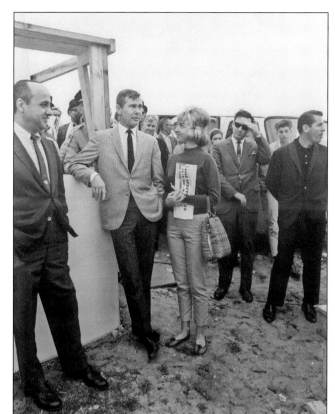

These two photographs show Johnny Carson (center) when he made an appearance at the groundbreaking of a new city called Coral Springs in 1964. Carson bought 60 acres at a discount price, which turned into the best investment he ever made. He kept the land for eight years and sold it at a tremendous profit. Today Coral Springs is a vibrant city with more than 130,000 residents.

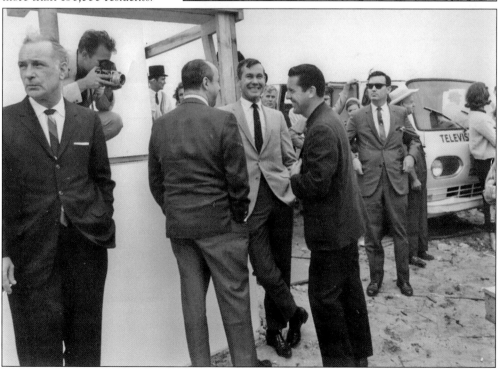

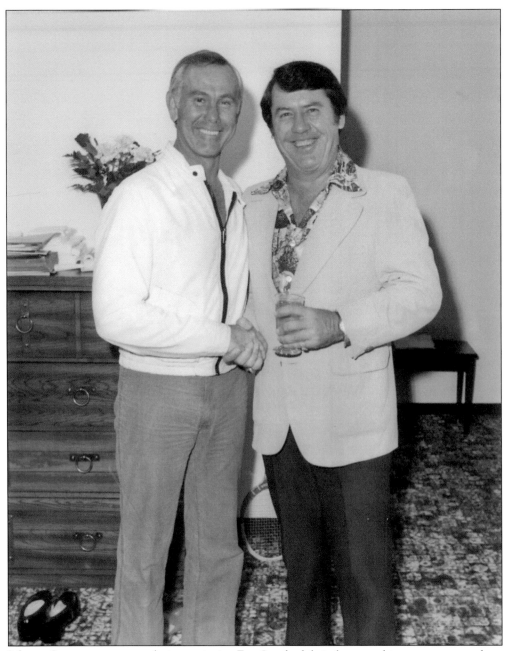

Johnny Carson spent so much time enjoying Fort Lauderdale in between his appearances as host of the *Tonight Show* that the author arranged for a year-round apartment at the Ocean Manor Hotel on the Galt Ocean Mile. This photograph was taken in 1965 after Carson received the keys to his personal paradise. (Courtesy of Ross Alan Photography.)

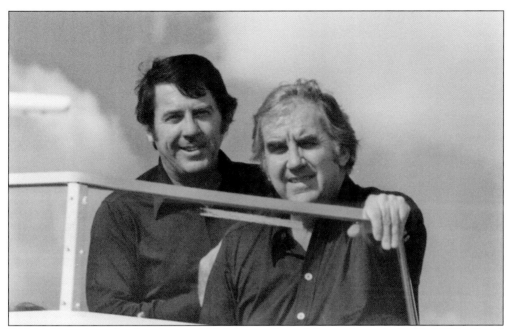

Ed McMahon (at right above) was a U.S. Marine Corps fighter pilot in both World War II and the Korean conflict and retired as a full colonel. He is shown here in 1975 with the author during a visit to discuss hosting an air show in Fort Lauderdale. The bottom photograph shows local business executive and Learjet owner Dave Ehlers, who knew that Johnny Carson was a pilot, so Ehlers offered him a ride back to New York in 1970 after a long weekend at Le Club International where Carson had been participating in a celebrity tennis tournament. Carson was an avid tennis player and built a tennis complex at his home in Malibu, California.

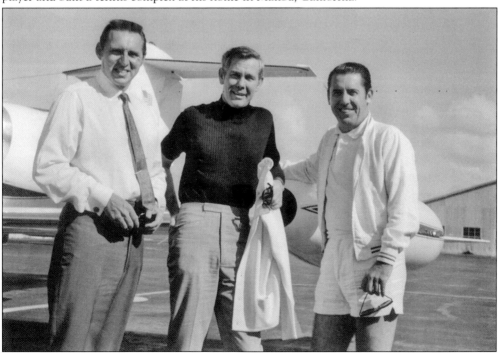

Born in Nebraska, Johnny Carson was mesmerized by the ocean and often chartered a yacht to go fishing. Shown in the top photograph in 1968 with Carson are the author's two sons, John (left) and Chris Drury. Below, Carson, with his hand on his knee, often brought his three sons, Cory (middle), Chris (behind Johnny), and Rick (far right), to Fort Lauderdale. Pictured here in 1967 taking a break from the beach, the Carson family visits a new upstart school out west called Nova for a little education on marine life. Carson's son Chris eventually moved to Fort Lauderdale and became an excellent golfer. (Above courtesy of Doris Barnes; below courtesy of Gene Hyde.)

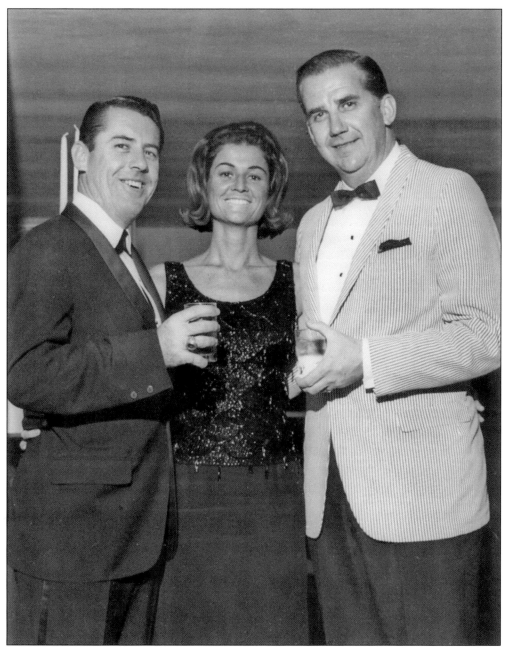

Generous Ed McMahon often volunteered his time to help local charities while visiting Fort Lauderdale. Here in 1968, McMahon is shown with the author and his wife, Marie, at a benefit for the Boy's Clubs. McMahon and Johnny Carson teamed up to entertain America for 30 years, so Ed is well known, and his appearance generates excitement. (Courtesy of *Fort Lauderdale News*.)

Appearing in 2005 to raise funds for the Wheelchair Foundation, Ed McMahon (above, center) met with his friend and one of Fort Lauderdale's most recognizable residents, billionaire businessman Wayne Huizenga (left). Huizenga's investments included such ventures as Blockbuster Video, the Florida Marlins, AutoNation, and the Miami Dolphins. The photograph below, the last one made of the author, Carson, and McMahon together, was taken on May 20, 1992, after a lunch at the Polo Lounge in the Beverly Hills Hotel in California. The gathering was celebrating the 30-year friendship with the author and Johnny Carson's final appearance as host of the *Tonight Show*. The final show aired later that week on May 22, 1992, to a record-breaking audience. Carson died at 7:00 a.m. on January 23, 2005, at the age of 79.

Three

JAYNE MANSFIELD
AND MICKEY HARGITAY

During the winter of 1962, the weather up north was freezing, and anyone with any sense preferred to be in sunny Florida. Most of the hotel rooms in Fort Lauderdale were already full except for a few rooms at the Jolly Roger Hotel (now called the Sea Club Hotel). The author represented the Gill Hotels, who owned the Jolly Roger, and arranged for Jayne Mansfield and her husband, Mickey Hargitay (a former Mr. Universe), to stay at the Jolly Roger. The couple arrived on February 5, 1962.

Mansfield, who was always seeking publicity, agreed to a press conference on the outside deck of the hotel, and the media delighted in taking photographs of her. Mansfield and Hargitay hit all the hot spots that first night, creating excitement wherever they went. They also discovered that the Gill Hotels owned the British Colonial Hotel in Nassau, Bahamas, and asked if they could take a trip there.

The author, Mansfield, and Hargitay flew from Fort Lauderdale to Nassau early on Wednesday, February 7, 1962. After checking into the hotel, it was arranged for the Bahamas News Bureau to take some publicity shots around 2:00 p.m. A crowd formed, so it was suggested that the session be continued away from the people with some water-skiing photographs. When the photograph session was over, Mansfield saw a little island in the distance and suggested the threesome motor over there for some quiet and peace.

Later that afternoon, a typical tropical storm came out of nowhere, and the threesome ran for cover on the island. The storm created such turbulence that the boat drifted off, darkness overtook them, and the threesome was stranded on the island all night wearing nothing but their wet swimsuits.

The photographs in this chapter vividly document what could have been a life-changing experience for the Hargitay and Drury families.

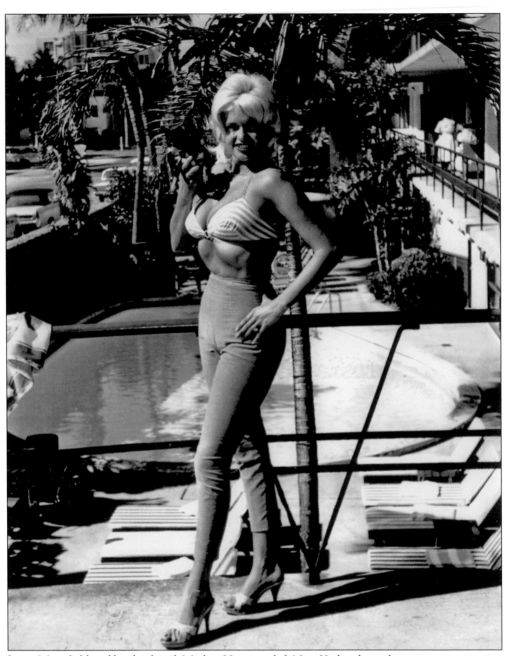

Jayne Mansfield and her husband, Mickey Hargitay, left New York, where they were experiencing a major snowstorm, to enjoy the warm sun of Fort Lauderdale. Anxious to get out of her cold-weather clothes, Mansfield is shown here on the deck of the Jolly Roger Hotel on the beach in Fort Lauderdale on February 5, 1962. Mansfield's career in movies was jump-started when she appeared as the Playmate of the Month in *Playboy* magazine in 1955 at the age of 22. She also won a Golden Globe Award in 1957 as the Most Promising Newcomer–Female for the film *The Wayward Bus*.

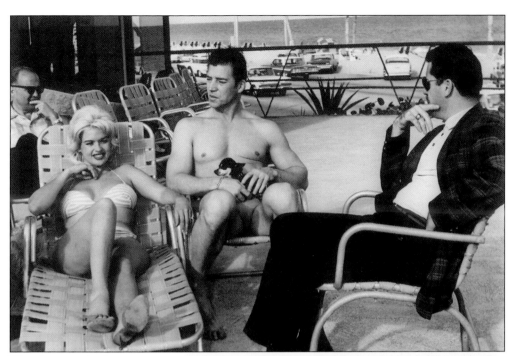

The photograph above shows Jayne Mansfield, who was joined by husband, Mickey Hargitay, relaxing in lounge chairs on the deck of the Jolly Roger Hotel located on the beach in Fort Lauderdale. The author, in the jacket, welcomed them to Fort Lauderdale as the guests of the Gill Hotels, who owned the Jolly Roger and three other hotels in town, and asked if they would agree to some publicity photographs. The photograph at right shows the couple getting a little Fort Lauderdale sun before the press arrived. A year earlier, Mansfield had appeared in her 12th movie, *The George Raft Story*, and was reading a script for her next movie, *It Happened in Athens*, which was filmed in 1963.

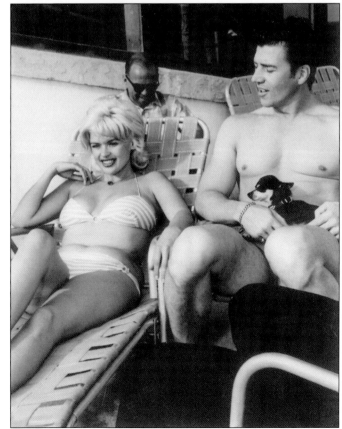

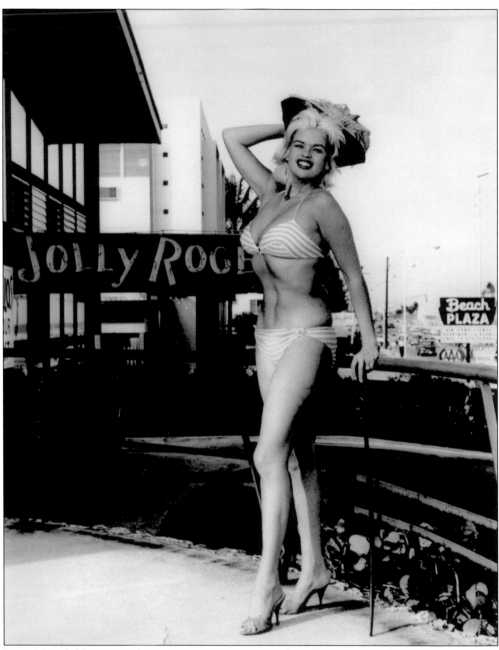

Jayne Mansfield continued to cooperate in promoting the Jolly Roger Hotel and Fort Lauderdale by posing in front of the hotel sign in a bikini. This photograph, taken in February 1962, certainly demonstrated her figure, which made her one of Hollywood's most sought after sex symbols. Mansfield had been married twice before and had given birth to five children, so she worked hard to keep in shape. Known mostly for her movie roles, Mansfield also appeared in four theater performances. She was 28 years old when this photograph was taken in Fort Lauderdale in February 1962.

Continuing the photo session on the deck of the Jolly Roger Hotel in February 1962, Jayne Mansfield and Mickey Hargitay hammed it up in the photograph at right. Mansfield put on a pirate hat and picked up a fake sword to chop off the head of Mickey. In the photograph below, they used the telescope to look for other pirate ships. The pair was having a good time because they also were celebrating their fourth wedding anniversary. That night they visited three other Gill Hotels and signed autographs.

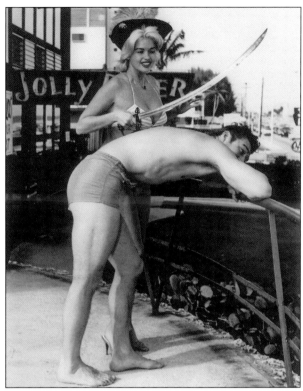

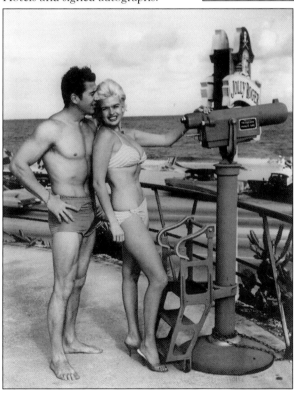

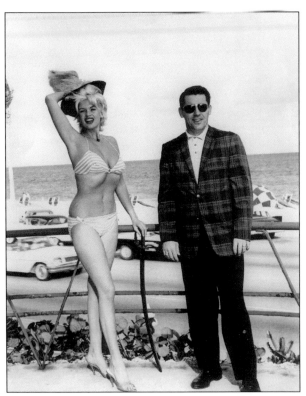

Jayne Mansfield was kind enough in the photograph at left to ask the author to stand next to her. Notice her ability to pull her stomach in to accentuate the positive. For a woman who birthed five children, she certainly liked to show off her attributes. One of the three children she had when married to Mickey Hargitay was Mariska Hargitay, born January 23, 1964. She followed in her mother's footsteps, making her first movie in 1983 at the age of 19. Mariska is best known for her television career, including her character in the popular *Law and Order* show. The photograph below was taken at the end of the photo session, when Mansfield and Hargitay decided to take a dip in the ocean. The author convinced Mansfield to wear a different bathing suit instead of the bikini to avoid a riot on the Fort Lauderdale beach.

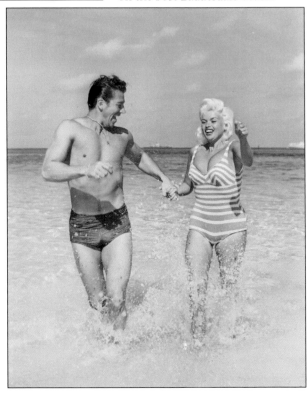

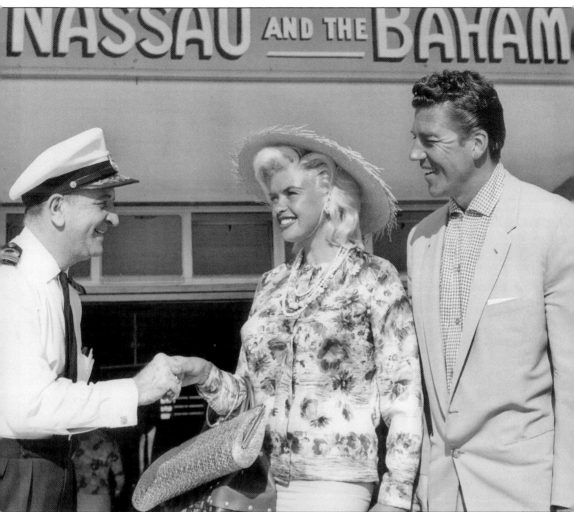

This unidentified captain of the Mackey Airlines, on whose plane Jayne Mansfield and Mickey Hargitay took from Fort Lauderdale to the Bahamas, says good-bye to the pair at the gate at the airport in Nassau, Bahamas. The Bahamas Tourist Board had already presented Mansfield with an island straw hat and had a car available to take them to their suite at the British Colonial Hotel, located on Bay Street in downtown Nassau. The couple arrived on February 7, 1962, and planned to spend two days enjoying this island paradise. (Courtesy Bahamas News Bureau.)

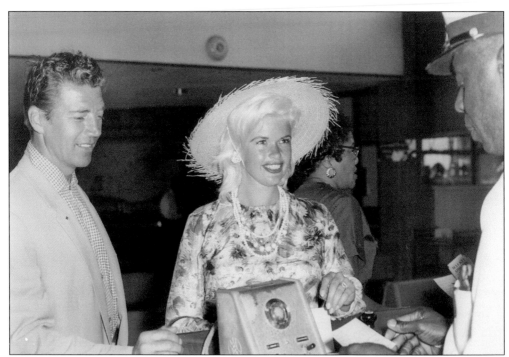

In the photograph above, before being transported to the British Colonial Hotel, Jayne Mansfield and Mickey Hargitay had to get clearance through customs. Since the two were world travelers, their passports were in order, and everything went smoothly. Most of the natives of the Bahamas did not recognize the movie star and her husband, which was different than in the United States. They enjoyed the privacy. The photograph below is a shot taken after the couple checked into the hotel and had a chance to visit an old friend, entertainer/singer Burl Ives, who was a frequent visitor to the Bahamas. (Both courtesy of Bahamas News Bureau.)

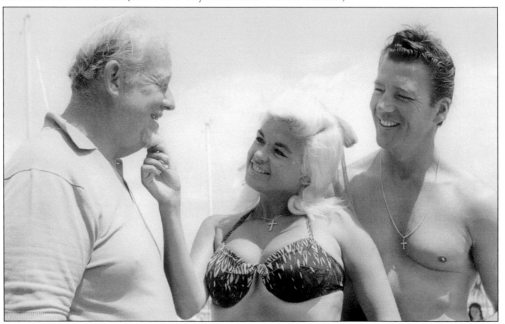

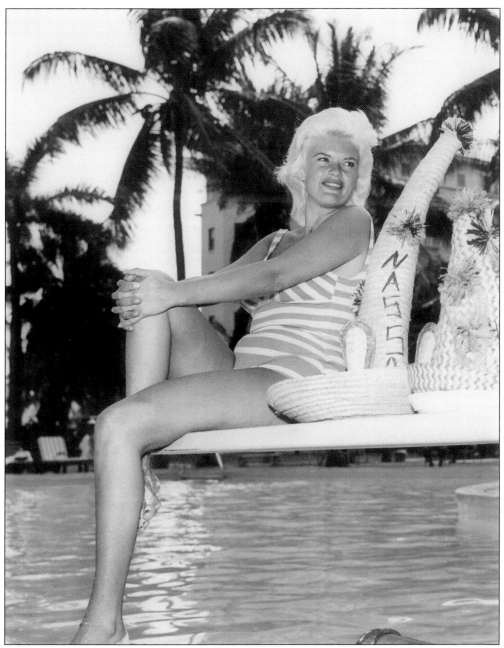

In 1962, the Bahamas Tourist Board was one of the best public relations agencies in the world at releasing stories and photographs about the Bahamas. The board had a team ready to spend a couple of hours taking publicity shots of Jayne Mansfield and Mickey Hargitay. This image was taken on the diving board at the pool at the British Colonial Hotel. The Bahamas News Bureau suggested Mansfield change from the brief bikini she had on when she met with Burl Ives into a one-piece swimsuit. (Courtesy of Bahamas News Bureau.)

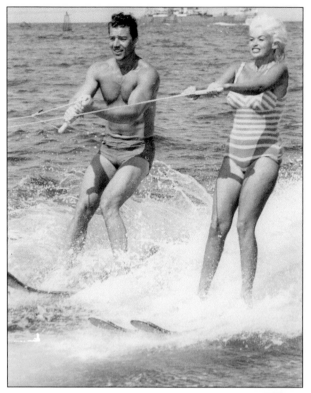

After an hour of photographs on the beach and at the pool of the British Colonial Hotel, the couple were asked if the Bahamas Tourist Board could take some pictures of them water-skiing. A boat was provided for Jayne Mansfield and Mickey Hargitay to ski behind, and the author was asked to drive it while a team of photographers motored nearby, taking the shots. Hargitay, being a great athlete and former Mr. Universe, was excellent on the skis and helped Jayne so she did not fall too often. (Both courtesy of Jarvis Studios.)

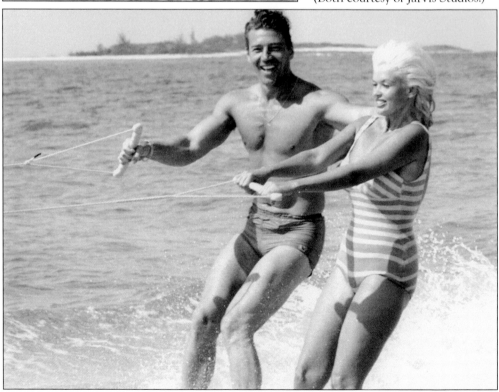

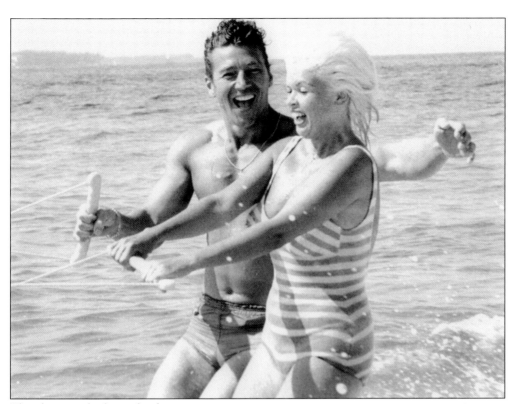

The photograph above clearly shows the fun that Jayne Mansfield and Mickey Hargitay were having water-skiing, but after an hour, the couple was getting tired, so the photographers were told that the photo session was over. The photograph below is a shot of the couple in the water after Mansfield fell down and Hargitay went to get her and her skis. After they got in the boat, it was decided to motor to a small, remote island to rest and relax. After another hour or so, a typical tropical thunderstorm came roaring in off the ocean. The boat broke loose and was smashed against the reefs. When the boat was not returned, the authorities were notified, and a small search party was dispatched about 9:00 p.m. It was Wednesday night, February 7, 1962, when the news broke all over the world that Mansfield was missing. (Both photographs courtesy of Jarvis Studios.)

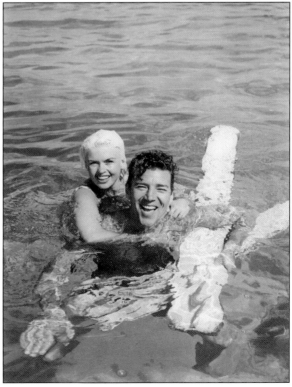

Chicago's AMERICAN

Always On Top Of The News

© 1962 by Chicago American Publishing Co.

3 STAR
★ ★ ★
EDITION

Scratches on Page 34

68 | Three Sections, Section I | THURSDAY, FEBRUARY 8, 1962 | Phone: 222-4321 | 1 | L | 7 CENTS

Push Air-Sea Search for Jayne Mansfield

Jayne Mansfield Hunted at Sea

[Continued from page 1]

the boat could not have been steered with the fitting broken, pearce said.

A gasoline tank which was in the boat when it departed Nassau apparently had drifted away.

An all night search failed to turn up any trace of the missing trio.

Jayne in Swim Suit

Jayne, in a brief swim suit, and Hargitay, a former Mr. Universe, skiied gaily out of Nassau behind the white hulled outboard motor boat driven by Drury, who accompanied them from Florida to Nassau.

The trio failed to return as planned at 4 p. m. and missed a scheduled news conference at 6 p. m. At 8:30 p. m. Capt. Durward Knowles, chief of the air-sea rescue unit, dispatched three craft to scour the area which remained calm to slightly choppy.

Mother of Three

Miss Mansfield has three children, two of them by her marriage to Hargitay. They are Jaynie Marie, 11, by her first husband; Miklos, 3, and Zoltan Anthony, 1.

The couple went to Fort Lauderdale for a vacation and decided on the Nassau trip to enjoy their hobby, water skiing. They had planned to do skin diving today.

Drury's wife said in Fort Lauderdale. "Jack is a good swimmer, I feel sure that if the boat capsized a quarter-mile off the island, there is an excellent chance he would have made ashore."

Drury, in his 30s, worked as a publicist for the Gill hotel chain, which includes the Jolly Roger where the Hollywood couple stayed in Fort Lauderdale and the British Colonial

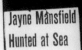

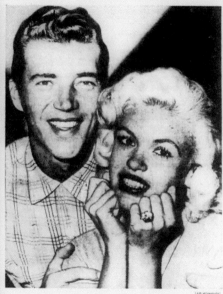

JAYNE MANSFIELD AND HER HUSBAND, MICKEY HARGITAY, MISSING AT SEA

(AP Wirephoto)

Lost with 2 Off Bahamas, Boat Found

How Jayne Mansfield's publicity knack led to success. See Page 4.

NASSAU, Bahamas (P—Shapely Jayne Mansfield, her husband, and a publicity man were sought by sea and air today after an overturned boat, identified as theirs, was found in waters where they went water skiing.

Search for the blonde film star, 28; muscular Mickey Hargitay, 32, and their Fort Lauderdale, Fla., companion, Jack Drury, centered around Rose Island 5 miles northeast of the Bahamas resort capital.

The United States coast guard at Miami sent a big Albatross amphibious plane at dawn to help Bahamas rescue units and volunteer yachtsmen sweep the seas in the area and scan the 9 mile long, half mile wide island which has no phones and only two or three cottages.

Searchers hoped the missing trio, strong swimmers, reached Rose Island.

The capsized boat—which resembled the 16 foot outboard that towed the water skiers out yesterday noon—was found afloat bottom up a quarter-mile off the island at sundown. A fisherman discovered it. The steering shaft bracket was broken.

Milton Pearce, veteran charter boat captain, examined it at Nassau and said, "There's no doubt this is the boat they went out with."

Pearce said the 16 foot white outboard craft was the only such boat for hire by its owner, who rented his craft to the water skiers.

The break in the steering column bracket was fresh and

[Continued on page 4, col. 5]

Since Jayne Mansfield, Mickey Hargitay, and the author did not return to the hotel for a 6:00 p.m. press conference the night of Wednesday, February 7, 1962, the Bahamas press office released the news that they were lost, and it was picked up all over the world. This photograph is a copy of the *Chicago American's* front page Thursday morning, February 8, 1962. The U.S. Coast Guard in Miami sent a big Albatross amphibious plane at dawn on February 8, 1962, and it was joined by 20 to 30 boats, all out to find the threesome.

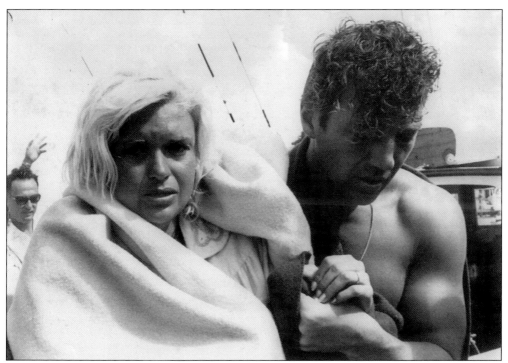

The photograph above shows a tired and cold Jayne Mansfield, wrapped in a blanket, being helped by Mickey Hargitay from the boat. After spending the entire night on the island, Mansfield had developed a major skin reaction, Hargitay had a large cut on his leg, and the author had received some cuts and bites. The photograph below is a shot of some of the huge press that gathered in Nassau to ask questions. A car took Mansfield to the hospital and returned Hargitay and the author to the British Colonial Hotel to get a hot bath, food, and a change of clothes before agreeing to a press conference at 2:00 p.m. (Both courtesy of Jarvis Studios.)

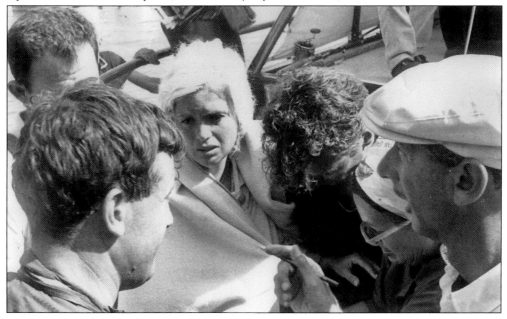

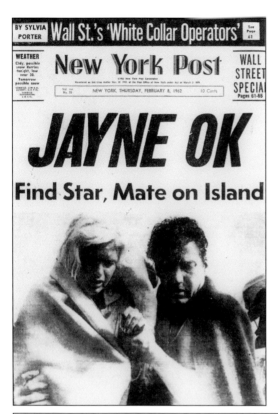

BY SYLVIA PORTER Wall St.'s 'White Collar Operators' See Page 61

WEATHER Cldy, possible snow flurries tonight, low near 30. Tomorrow possible snow

New York Post

WALL STREET SPECIAL Pages 61-65

NEW YORK, THURSDAY, FEBRUARY 8, 1962 10 Cents

JAYNE OK

Find Star, Mate on Island

These are just two samples of the press coverage this accident received all over the world. In the photograph at left, the front-page headline from the *New York Post* said, "Jayne OK." The photograph below is the headline in the author's hometown of Fort Lauderdale on Thursday, February 8, 1962. The night before, when the news carried the fact that the threesome was lost, friends tried to comfort the author's wife, Marie, and their four children. A private airplane was chartered to fly Marie over to Nassau early Thursday morning, where she received the good news about the rescue.

THE WEATHER Partly cloudy through tomorrow. Few scattered showers today. High today 75 to 80. Low tonight 65 to 70. For complete weather information see Page 2-A.

FORT LAUDERDALE NEWS

HOME EDITION

AP Wirephoto Photofax Member Of The Associated Press And UPI *Full NEA Service*

52nd Year Five Sections FORT LAUDERDALE, FLORIDA, THURSDAY, FEBRUARY 8, 1962 74 Pages N S PRICE FIVE CENTS

JAYNE, HUSBAND FOUND SAFE
WITH LOCAL PRESS AGENT

JACK DRURY
... a good swimmer

Dad's In Boat, Children Told

By SEYMOUR BEUBIS
(News Staff Writer)

When public relations man Jack Drury was reported missing in Bahamian waters with actress Jayne Mansfield and her husband, the three Drury children old enough to understand were told simply:

"Dad is in a boat that is out of gas."

"We had to tell them something," said Mrs. Richard McDonough, Drury's mother-in-law. "They heard something on the radio and we tried to explain without worrying them.

"Thank God now that Jack is safe, they'll never have to know how serious it was."

The Drurys have four youngsters, Johnny, 8, and Chris, 7, both who attended classes at St. Coleman's this morning; Susie, 4, and Linda, seven months old.

When Mrs. Drury took a flight to Nassau this morning, her neighbors took over the care of the children and the household chores.

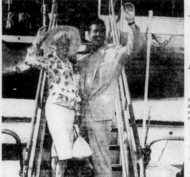

Boat Fails, Trio Spends Night On Isle

By CHARLES McGRATH
(News Staff Writer)

NASSAU — A giant air-sea hunt for Actress Jayne Mansfield, her husband, Mickey Hargitay, and Ft. Lauderdale hotel promotion man Jack Drury, had a happy ending today when the trio was found safe on an island near this British resort.

The buxom blonde and her companions touched off the search yesterday after their 16-foot outboard motor boat was discovered capsized about a half mile off Rose Island.

The 28-year-old actress, her husband and Drury apparently swam to the secluded island.

Miss Mansfield was clad in a one-piece blue and white striped bathing suit. Her companions wore swimming trunks.

Events leading up to their refuge on Rose Island—a favorite spot with partakers—could not be learned immediately.

Officials reported the trio suffered "slight exposure" because they were in bathing suits and the unusually milder temperatures.

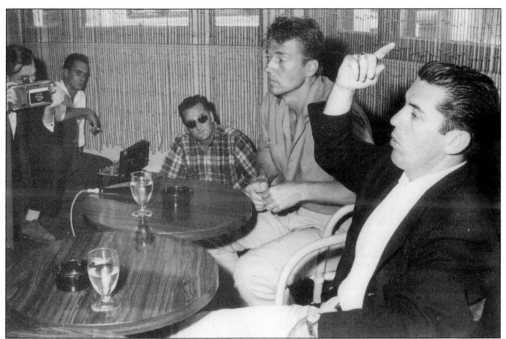

The photograph above was taken at 2:30 p.m. on Thursday, February 8, 1962, at the British Colonial Hotel in Nassau during the press conference requested by the Bahamas authorities. The author and Mickey Hargitay had taken a hot shower, had some food after eating nothing the night before, and had started answering the questions from the cynical press. The photograph below shows Hargitay exhausted from the ordeal, finally letting his emotions take over because of all the negative questions, particularly as to why Jayne Mansfield was not at the press conference. Mansfield was still in the hospital being treated for exhaustion and exposure. (Both courtesy of Jarvis Studios.)

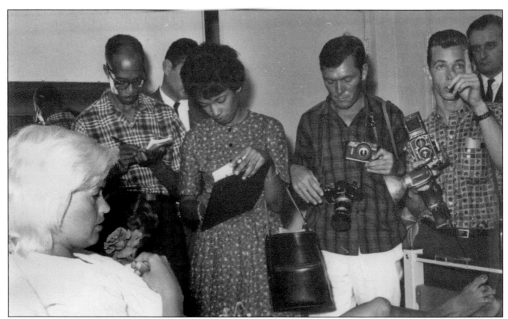

In order to appease the persistent press, Mickey Hargitay agreed to allow a small group to go to the hospital to talk to Jayne Mansfield. The photograph above shows Mansfield in her hospital bed enjoying some flowers sent by her children. She was so exhausted from the ordeal that she did not care about her hair, make-up, or her hospital gown. The photograph below shows Hargitay answering more questions while Mansfield stares into space, recalling the awful night and the fact that she was still alive. (Both courtesy of Jarvis Studios.)

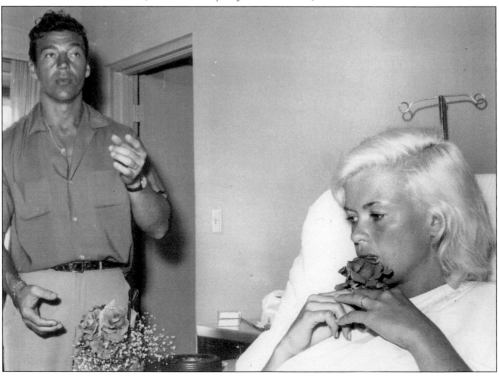

Waiting for the press to finish interviewing Jayne Mansfield in the hospital are an exhausted Mickey Hargitay (top right), the author (center), and the author's wife, Marie. A disgusted Hargitay was tired of the press downplaying how cold it was that night on the island. He finally challenged all of them and said he would be back in a few weeks, rent some boats, and take the press out wearing only bathing suits, make them take a swim in the ocean, and he would pick them up the following morning. He only asked that they write the truth. The photograph below is a shot of the author's family greeting him and his wife, Marie, at the airport upon returning to Fort Lauderdale on February 9, 1962. Pictured from left to right with the author is son Chris (wearing the hat), daughter Sue, wife Marie, Marie's mother, and Linda. Son John is hidden from the camera. (Right courtesy of Jarvis Studios.)

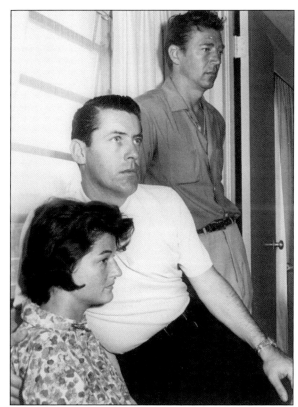

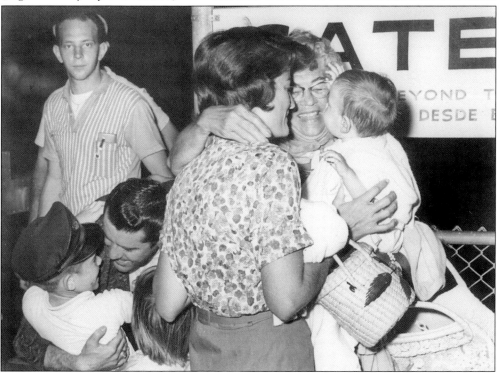

MANSFIELD & HARGITAY

Productions

BRADSHAW 2-7007

10100 SUNSET BOULEVARD, LOS ANGELES 24, CALIFORNIA

February 28, 1962

Mr. Jack Drury
P. O. Box 4037
Fort Lauderdale, Florida

Dear Jack:

Thanks so much for your letters and telegram. As you can imagine and as you know, neither of us thought at the time (because we were only concerned with saving our lives) the reactions it would bring. I don't want to go into all the major details but the reaction we received was just overwhelming - we have been flooded with telegrams and letters - as far away as Hungary.

But you know one thing, after this accident my whole outlook on life is much rosier. I now appreciate life more.

Hope that Marie is doing well now and the children are fine.

Once again I want to thank you for all you have done for us. You have shown yourself to be a true friend. Please give our regards to everyone there and if you ever visit California we always have room for you.

Your friend,

Mickey

The weeks that followed the February 8, 1962, accident in the Bahamas were hectic for Jayne Mansfield, Mickey Hargitay, and the author. This photograph of a copy of Hargitay's letter to the author stated that the reaction they received was "overwhelming." The author was approached by the *National Enquirer* to do an article on how it was to spend a night on a remote island with Mansfield wearing only a bathing suit. They were looking for a sensational angle to this terrible accident. The popular Ed Sullivan television show wanted the author and Mansfield to appear on the national show together in bathing suits. These requests, plus all the letters and calls from the author's friends, made it challenging for many months. The three survivors turned down all the requests. This is the first time that this story and its pictures have been published.

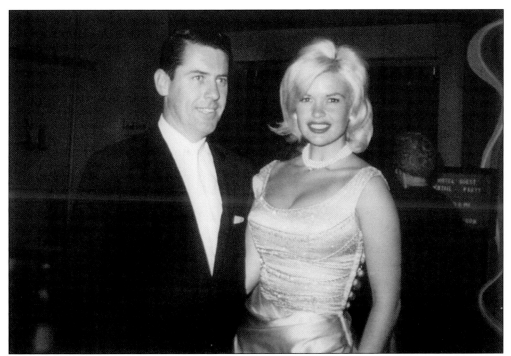

Jayne Mansfield was so appreciative of surviving the Bahamas accident on February 8, 1962, that a month later she said she was available to come to Fort Lauderdale to help the author promote his clients—for free. The photograph above was taken in the lobby of the Lago Mar Hotel upon her arrival on March 27, 1962, to Fort Lauderdale. The resort was one of the author's clients. The photograph below is a shot of Mansfield (center), the author's wife, Marie (left), and the author enjoying lunch on the patio of the Lago Mar Resort, which both then and now features the most beautiful, wide beach in Fort Lauderdale. (Both courtesy of Ken Twaddell.)

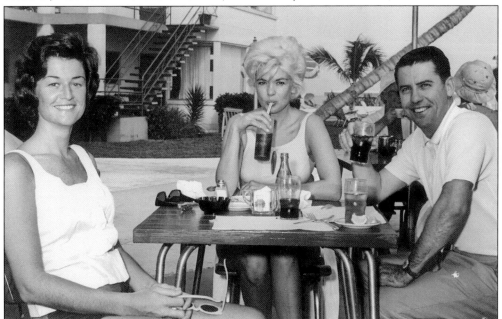

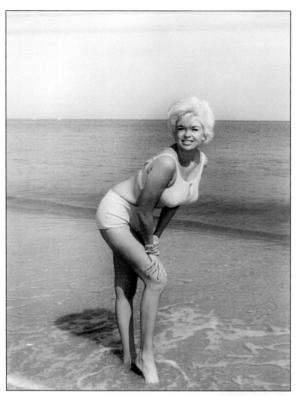

As always, Jayne Mansfield was ready for photographs and to do anything to help the author's client, the Lago Mar Hotel. The photograph at left shows her down at the ocean's edge at the bottom of the huge beach of the Lago Mar Hotel. The photograph below was taken on the patio after Mansfield spent hours signing autographs and posing for private photographs for the delighted guests of the private resort. Before Mansfield made the trip to Fort Lauderdale, the author had signed up a new client in a small, sleepy town in Central Florida called Orlando. It was a jai-alai fronton, and they wanted Mansfield to come up for an appearance. This was in 1962, years before Disney made Orlando the thriving resort it is today. Mansfield and her husband, Mickey Hargitay, agreed to fly to Orlando and make an appearance. This was the biggest thing to hit Orlando in years. (Both courtesy Ken Twadell.)

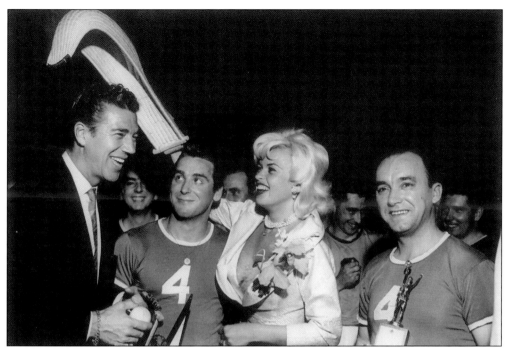

The trip from Fort Lauderdale to Orlando to appear at the author's client, the Orlando-Seminole Jai-Alai, was not uneventful to say the least. Jayne Mansfield was wearing a tight, baby blue–colored satin suit with a very low neckline. During the flight, Mansfield's zipper in the back of the dress split open. She was escorted to the bathroom, and a stewardess brought the dress back to Hargitay, who whipped out a small sewing kit to repair the damage. The author asked the pilot to circle until Mansfield could redress. The photograph above shows Mansfield and Hargitay being welcomed by two unidentified jai-alai players. The photograph below certainly demonstrates how low the neckline was on the repaired dress. (Both courtesy of Sentinel-Star Studios.)

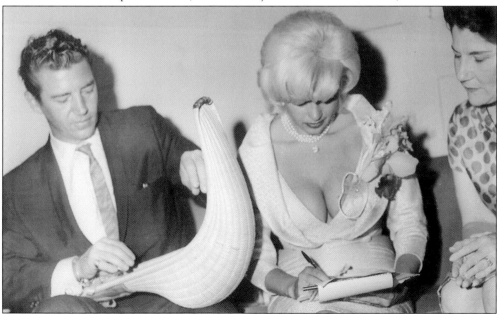

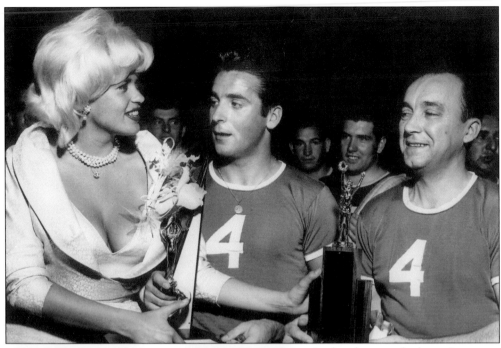

In the photograph above, Jayne Mansfield was called on to pose with two unidentified jai-alai players and their awards for the night. The photograph at left made the author nervous, knowing the condition of the recently sewn-up zipper on the back of Mansfield's dress. This was the last time the author saw Mansfield and Hargitay. The two divorced in May 1963, and she remarried a film director, Matt Cimber, in September 1964 and had another child. They divorced in 1966. Mansfield was in a car accident on June 29, 1967, on her way to an appearance in Biloxi, Mississippi, with three of her children, including actress Mariska Hargitay, who was three at the time. The children, all in the back seat, survived, but Jayne and her attorney, Sam Brody, were killed. (Both courtesy of Sentinel-Star Studios.)

Four

CARY GRANT AND BOB HOPE

Thank you, England, for birthing and sending over two of the most talented people to ever become a part of the fabric of America. Archibald Alec Leach, born January 18, 1904, in Bristol, England, changed his name to Cary Grant in 1931 when he first came to Hollywood, California. After a brief success on Broadway, he went on to star in 72 films, entertaining audiences as a lover, a warrior, a comedian, a hero, and more. He was recognized as one of the most versatile actors ever on the screen.

In 2004, Grant was named "The Greatest Movie Star of All Time" by *Premiere Magazine* for his meaningful work as an actor. Grant was married five times but only had one child, a daughter with his fourth wife, Dyan Cannon, whom he married on July 22, 1965. This chapter will cover the time Cary, Dyan, and baby Jennifer visited with the author in Fort Lauderdale in 1966 on their return from England aboard the cruise ship *Canberra*.

Leslie Townes Hope was born in England on May 29, 1903. He was the fifth of seven boys. The family moved to Cleveland, Ohio, in 1908, and Hope became a U.S. citizen in 1920. Taking the first name of Bob, he started in show business at the age of 12, appearing in vaudeville, then on Broadway, radio, television, movies, and tours overseas entertaining our troops. Few entertainers ever had success in so many different areas of show business.

The author met Hope in 1977 at a PGA tournament hosted by Ed McMahon in Iowa, and in 1987, the author became a consultant to Hope Enterprises, working on eight Bob Hope/NBC television specials. This chapter will cover two of those specials, both taped in Florida.

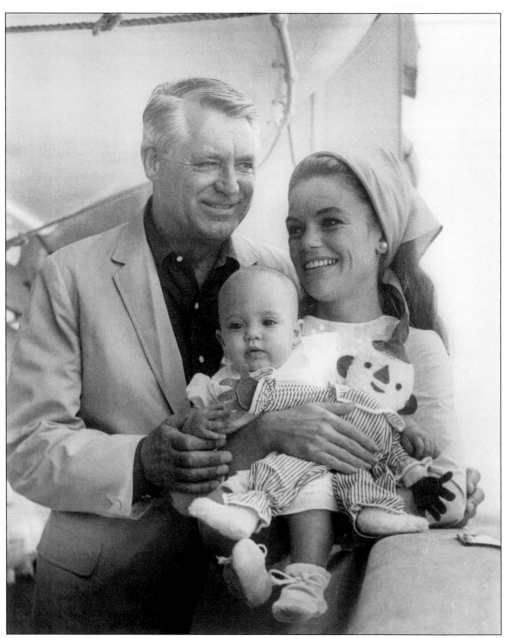

Cary Grant married actress Dyan Cannon, his fourth wife, who was 33 years his junior, on July 22, 1965, in Las Vegas. Cannon presented the movie icon with his first child on February 26, 1966, when Grant was 62 years old, and they named her Jennifer. In an interview, Grant made the comment that he hoped his ailing 93-year-old mother would see the baby before she died. The author seized this opportunity and called Grant's manager, offering the Grants a free round-trip cruise to England if he would agree to do a press conference at each port. One of the author's clients in 1966 was P&O Orient Lines, and the organization jumped at the opportunity to have this legend on their ship. In this photograph, Cary and Dyan with baby Jennifer were aboard the *Canberra* when it arrived at Port Everglades in Fort Lauderdale, Florida, in 1966 on the way back from England. (Courtesy of *Fort Lauderdale News*.)

The photograph at right shows one of the world's most well known movie stars coming down the ship's gang plank onto Fort Lauderdale soil, looking like he was starring in one of his movies. Not a hair out of place and with his Cary Grant swagger, he approached the author to discuss what was planned for the seven-hour layover before the ship sailed that evening. In the photograph below, the Grants are shown arriving at the Pier 66 Hotel for lunch to talk about the day. During the lunch it was learned that Jayne Mansfield had told Cary about the 1962 Bahamas accident with the author and Cary wanted to hear all the details. This was frustrating to the author because he had many questions to ask the living legend. Cary made a movie with Mansfield in 1957 called *Kiss Them for Me*. (Below courtesy of Joseph Burns Brocas.)

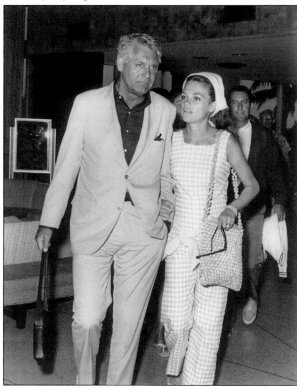

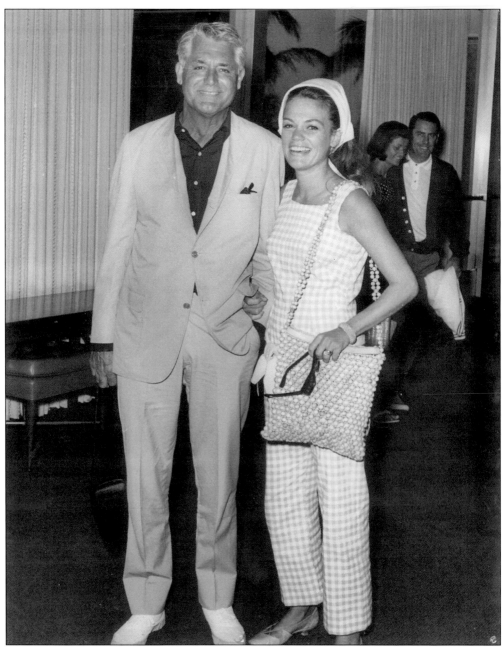

During lunch at the Pier 66 Hotel in May 1966, Dyan Grant said she loved to water-ski and wanted to know if there was any chance of doing that before going back to the *Canberra* to continue their cruise home. The author called his friends Dick and Barbara Fast, who owned a boat, and asked if they could motor over to the hotel and pick the group up. After a quick trip back to the ship for a bathing suit for Dyan, everyone was off for a day of skiing on the waterways of Fort Lauderdale. (Courtesy of Joseph Burns Brocas.)

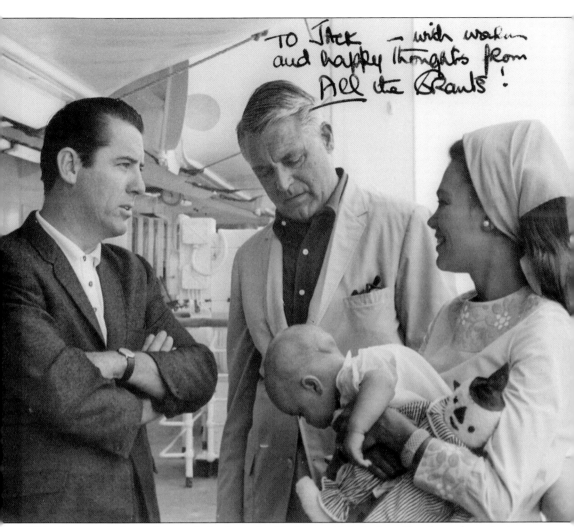

This photograph shows the couple back on the *Canberra* with baby Jennifer after a day enjoying Fort Lauderdale. Dyan Grant changed back into a dress, and the ship left to continue the voyage back to Los Angeles. The couple divorced in 1968 with a bitter and public custody fight over Jennifer. Cary Grant married his fifth wife, British-born Barbara Harris, in April 1981.

TEL. POPLAR 9-0500
TRIANGLE 7-1211

CABLE ADDRESS ARYRANT

CARY GRANT

UNIVERSAL STUDIOS

UNIVERSAL CITY, CALIFORNIA

October 13, 1966

Dear Jack —

Thank you for the photographs, the clippings,
the latest news of Florida; and, yet again, for
the delightful day we spent with you and those
kind hospitable Fasts. Diane, I think, received
a note from Barbara Fast about the babys' arrival;
so please give them our best wishes and congratu-
lations.

No, I don't know what happened to the Dodgers.
We left that restful "Canberra" in order to permit
me to attend my first World Series games. The two
that were played in Los Angeles at least. But,
after Willy Davis missed those two catches, I
closed my eyes. So I don't know what happened to
the Dodgers. Neither do the Dodgers.

Enclosed is the photograph you wished signed.
The other, the one you sent separately, is a joy.
How kind of you to remember. Any others that in-
cluded the baby (there are three charming ones
taken with Diane on your strip) would be welcome
and I'd be glad and willing to pay your photo-
grapher for a few 8" x 10's".

Gratefully, Jack, and with Dianes' and my fond
regards to your wife.

Cary.

GRANOX – GRANSTAN – GRANLEY PRODUCTIONS

Despite his status as a super star, Cary Grant had the courtesy to write a letter to the author about his day in Fort Lauderdale. This letter opened up the door for the author to continue a friendship. They met many times in Beverly Hills, California, or New York City from 1966 to 1983. In the last few years of his life, Grant toured the United States in a one-man show called *A Conversation with Cary Grant*. He brought his one-man show to Broward County Community College in December 1983 and invited the author to the show and dinner afterwards. This talented gentleman of the movies, a true star, died just before doing a personal appearance in Davenport, Iowa, on November 29, 1986, at the age of 82.

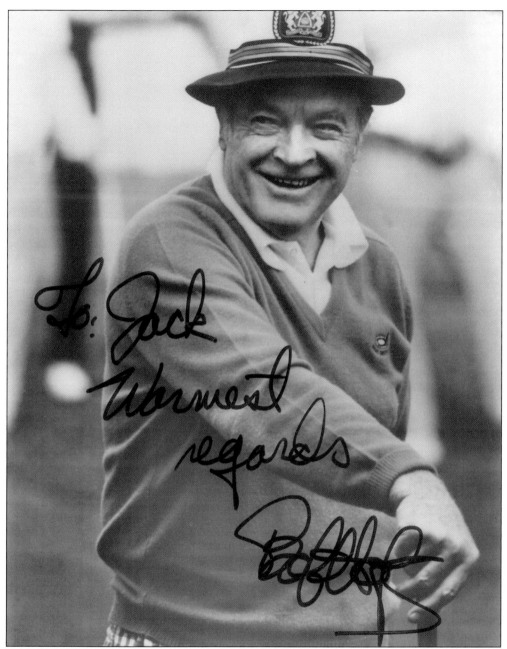

To: Jack
Warmest
regards
Bob Hope

Bob Hope was truly a golf fanatic. He thoroughly enjoyed the game, whether he was watching it, talking about it, or playing it. At one time, Hope was a low handicapper and even played in the British Amateur Tournament. Because of his love of the game, the Professional Golf Association (PGA) asked him to be the host of a tournament played in Palm Springs, California. He convinced one of his television sponsors to join him, and even today, the PGA Tour still has the Bob Hope Chrysler Classic as one of its most successful events. Hope signed this photograph for the author in 1990 when the author was invited to go to Palm Springs to play in the Hope Classic.

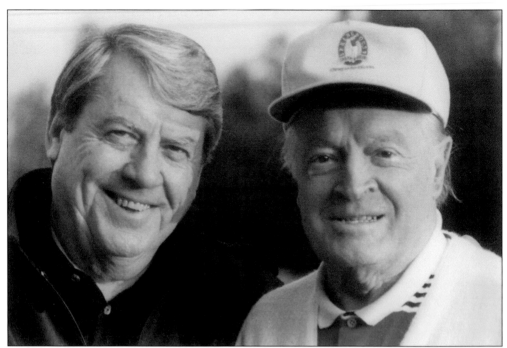

In 1987, Bob Hope agreed to tape his Bob Hope/NBC Christmas special in Fort Lauderdale. The theme of the show was centered on the annual Winterfest Boat Parade (see Chapter Eight for more pictures). Hope and his film crew of 60 people arrived in Fort Lauderdale on December 5, 1987, and spent five days taping the one-hour special, which was viewed by 30 million people when it aired on December 19, 1987. The author, shown with Hope in the photograph above, escorted him to all five locations and ended the day playing nine holes of golf at Coral Ridge Country Club.

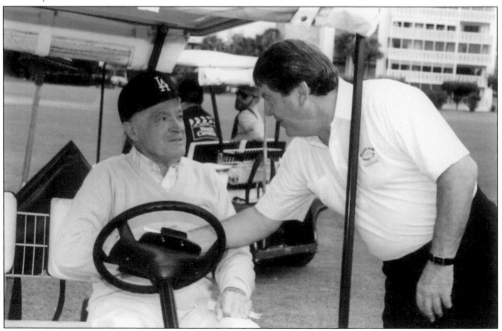

One of the locations used for the Bob Hope Christmas special was the Sunrise Musical Theatre in Sunrise, Florida. This segment featured Morgan Fairchild, shown with Hope on stage in the photograph at right. Also featured on the NBC television special were Reba McEntire, Brook Shields, and Tony Randall. At the end of the taping at the Sunrise Musical Theatre, Hope was given an award from Broward County and Fort Lauderdale. The photograph below shows Nicki Grossman, director of the Broward County Tourist Board, presenting the award as the author stands in the background (Right courtesy of Steven Casper; below courtesy of John Pearce.)

59

BOB HOPE

February 8, 1988

Mr. Jack Drury
Chief Executive Officer
Harris & Drury Advertising
6360 N.W. 5th Way, Suite 300
Ft. Lauderdale, FL 33309

Dear Jack,

Thank you for your letter -- We were really
lucky with our show down there and NBC was
sure happy. And I haven't talked to anybody
that didn't marvel at the fact that we produced
snow in Ft. Lauderdale in December.

I want to thank you for all your help and I
hope someday we can put a golf game together.
I need a little money after that SuperBowl....
Washington got to me again.

Great hearing from you.

Regards,

Bob

BH/mm

For many years, every Bob Hope Christmas special had a scene where Hope and his female guest would sing the song "Silver Bells" in a winter setting. The local coordinators answered that by blocking off a street on Las Olas Boulevard on Sunday, December 6, 1987. A fake snow machine was brought in to totally cover the street and sidewalks. When Hope and Reba McEntire starting singing, a snow blower from the roof of the Riverside Hotel sprayed what looked like snow down on the couple. Another miracle performed for the Christmas special was a scene shot the evening of December 7, 1987. The actual Winterfest Boat Parade was not until Saturday, December 12, but a group of 10 boats agreed to decorate early. As Hope ended his television show, they appeared in the background. This letter, sent to the author from Hope, demonstrates how happy he was with doing his special in Fort Lauderdale. In fact, he called his show, "A Snow Job from Florida"—please notice, he also talked about his real love—golf.

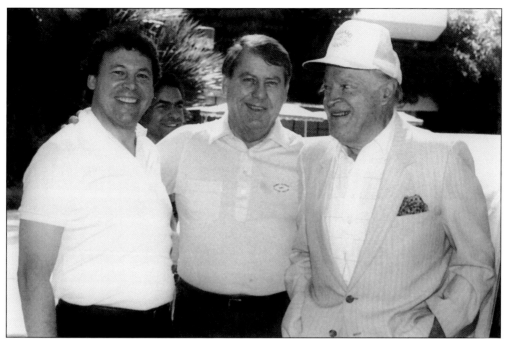

The Bob Hope 1987 Christmas Special was taped in Fort Lauderdale in early December 1987 and aired on December 19, 1987. It was so successful that the author enticed Hope back to South Florida to do another television special a year later in December 1988. Taping was done at many locations, including Williams Island in North Miami. The photograph above shows an unidentified member of the staff of Williams Island (left) with the author and Hope discussing locations for the show. Hope, always looking for a golf game, joined Fort Lauderdale resident and professional golfer Julius Boros (center) and the author for an 18-hole match prior to the taping. (Above courtesy of Fred Hoblitz.)

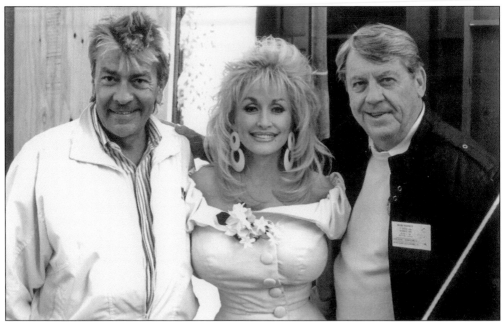

Hope was a big admirer of Dolly Parton because, like him, she excelled in many areas. Parton, who was 42 when this photograph was taken with Dick Arlett (left) and the author (right), was not only a Grammy Award–winning country singer, but also a songwriter, composer, musician, author, actress, and philanthropist. Her short height and thin waist accentuated her 40-inch bustline, which attracted many offers to appear in men's magazines, but she turned them all down, including *Playboy* magazine. The photograph below was taken at the end of the taping at the Fort Lauderdale Executive Airport with Lear pilot Harvey Hop and the author. Hope, who was 85 at the time, needed to fly to Orlando, Florida, to do a personal appearance. Hope had many awards and honors over the years but treasured the Congressional Gold Medal Award as his finest. He also achieved another milestone by living to be more than 100 years old, with his death on July 27, 2003, a few months after his 100th birthday.

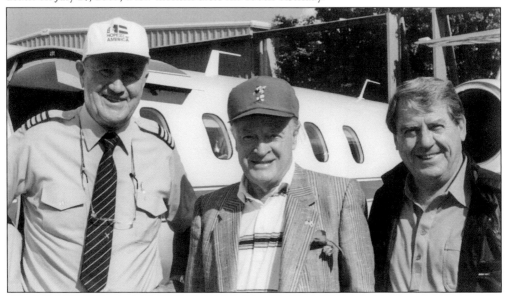

Five

BILLIE JEAN KING AND BOBBY RIGGS

Tennis has always been popular in Fort Lauderdale, with many private, public, and resort tennis courts available for the locals and the tourists. The city-owned tennis courts in Holiday Park on Sunrise Boulevard, supervised for many years by a teaching pro, Jimmy Evert, produced some top-name players. The most famous, of course, was his daughter Chrissy, who had a unique playing style that featured a two-handed backhand. This revolutionized women's tennis because it allowed more power to the backhand shot.

Fort Lauderdale attracted tennis professionals and tennis-playing celebrities from all over the world (see Chapter Seven). One of the all-time tennis greats to frequently visit Fort Lauderdale was Billie Jean King, the player who was the biggest influence behind the success of women's tennis. The author was teamed with King in a tennis pro-am match in Fort Lauderdale at Le Club International in 1971 and seized that opportunity to become her agent. The author was at her side at the "Battle of the Sexes" against Bobby Riggs in September 1973. After that famous match televised from the Houston Astrodome, the author met Riggs and became his business manager.

Despite all the media coverage about Riggs being a promoter and a hustler in tennis, golf, cards, and backgammon, Riggs was an accomplished tennis player who was the No. 1 player in the world as an amateur in 1941 and again as a professional in 1946 and 1947. Being the promoter that he was in his later years, Riggs took on the role of a male chauvinist, claiming women's tennis was inferior. He challenged top female player Margaret Smith Court and beat her 6-2, 6-1 on Mothers Day, May 13, 1973. The media, and other women players, convinced Billie Jean King to accept Riggs's challenge. Each player was offered $100,000 to play, with the winner getting an additional $100,000—a lucrative offer for 1973.

This chapter will cover the many times that Billie Jean King and Bobby Riggs came to Fort Lauderdale.

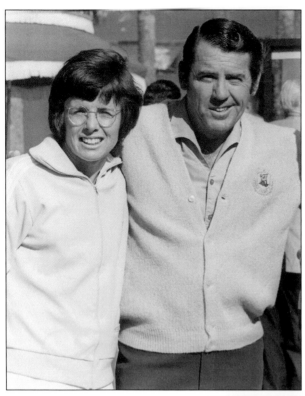

In 1971, Billie Jean King visited Fort Lauderdale to play in a pro-am event at Le Club International, and the author was one of the amateur players (as shown in the photograph at left). By this time, King was the main star on the women's tennis tour, and the author became her agent. Her manager at the time was her husband, Larry King, whom she married in 1965 at the age of 22. The photograph below was taken prior to a press conference to promote the Virginia Slims Tour in 1972. The person in the middle is unidentified. Virginia Slims was a women's cigarette introduced by Phillip Morris, and the marketing team at Virginia Slims came up with the idea of underwriting the fledging women's tennis tour across the country. (Left courtesy of Roy Erickson.)

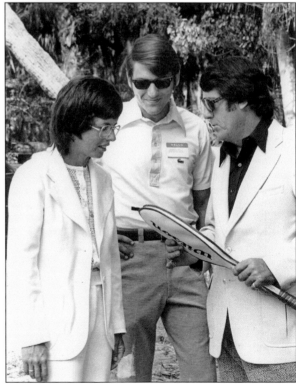

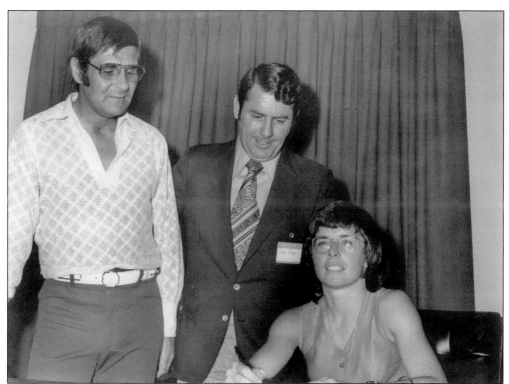

In many sports, particularly golf and tennis, it is good marketing to pay a professional to represent a company because the sponsor's name usually appears in programs, media, and so forth. In 1973, the author approached the Palm Aire resort, located just north of Fort Lauderdale in Pompano Beach, to sign Billie Jean King as their touring tennis professional. The photograph above was taken at the formal signing with, from left to right, Don Allison, vice president of Palm Aire, the author, and King. The photograph below was a publicity shot to be used to help market the connection of this world-famous tennis star, who was ranked No. 1 in the world in 1972 and 1974, and Palm Aire.

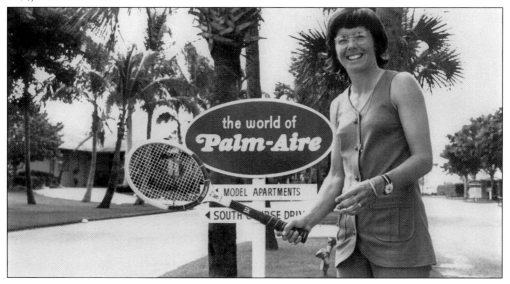

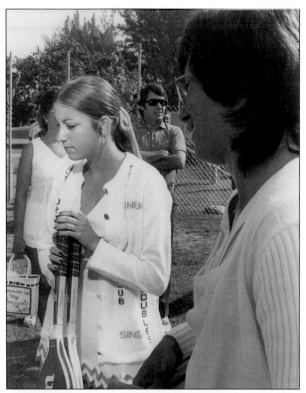

The photograph at left is a picture of a young Chris Evert (left) and Billie Jean King, who was often called "the old lady." At this time in 1971, Evert was only 17 years old, and King was 28. Evert was still an amateur but had already beaten many professional players. Her precise ground strokes made her a relentlessly accurate baseline hitter. The two later became big rivals and great friends, and it all started here in Fort Lauderdale, where Evert was born on December 21, 1954. The photograph below was taken at a press conference after one of the Virginia Slims tournaments. Evert turned professional in 1972, and she continued her success with a career record of 1,309 wins and only 146 losses. A product of Fort Lauderdale, she was No. 1 in the world in 1975.

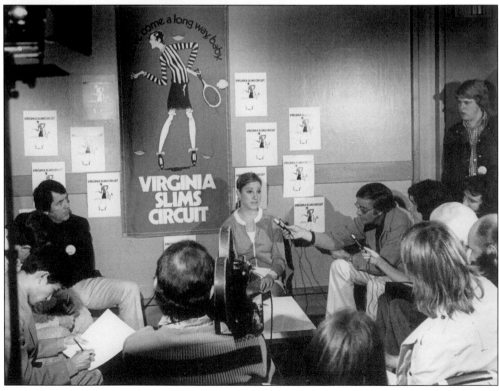

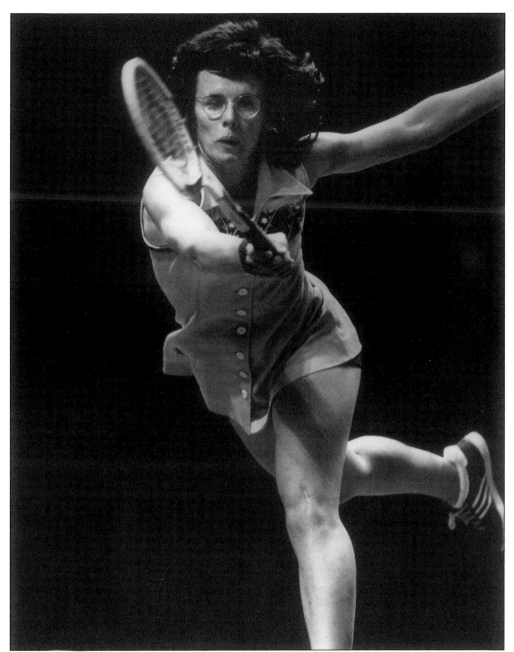

Billie Jean King was credited for making women's tennis a success. She was one of the best ever to play the game, with rankings as No. 1 in the world numerous times, including in 1971 when the author met her in Fort Lauderdale. She was constantly called on to do press interviews. In the early days of her professional career, which started in 1968, the press in every town the tour played always asked to interview King, and she made herself available despite her practice and personal schedule. King was a great athlete in a family that also produced her brother Randy Moffitt, who played professional baseball, pitching for 12 years in the major leagues. This photograph demonstrates one of her biggest assets—her strong legs, which carried her to more than 695 victories.

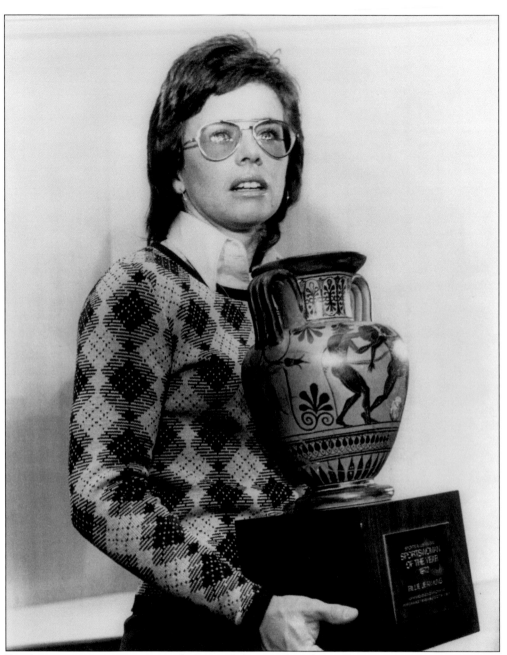

Besides winning tournaments and 12 grand slam single titles, Billie Jean King worked hard to improve the status of women's tennis by campaigning for equal prize money for women's tennis. In 1973, King became the first president of the women's players union, and in 1974, she founded a magazine called *Women's Sports*. She also helped to start world team tennis, and she was the captain the U.S. Fed Cup team, which won the championship in 1996. This photograph, taken in 1972, shows King holding an award from *Sports Illustrated* as Sportswoman of the Year. This was the first time a tennis player received the honor. (Courtesy of *Sports Illustrated*.)

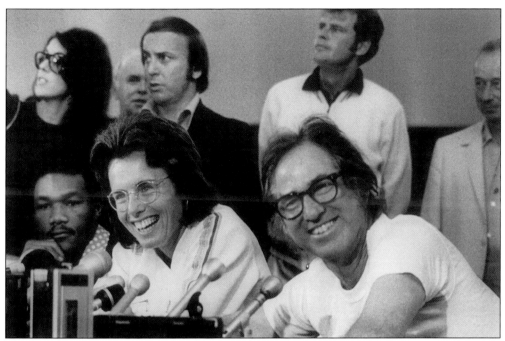

The photograph above is Billie Jean King and Bobby Riggs at a press conference in Houston, Texas, the day before the "Battle of the Sexes" at the Astrodome on September 20, 1973 (all others in the photograph are unidentified). Riggs deliberately played the male chauvinist role and came out of retirement to prove that the female game was inferior—at the age of 55 he challenged that he could beat any woman. He did that on Mother's Day, May 13, 1973, by beating Margaret Smith Court 6-2, 6-1. King took up Riggs's challenge on behalf of women and trounced the chauvinist 6-4, 6-3, 6-3 (the Battle of the Sexes agreement was for three sets). The photograph below was taken at Le Club International in 1974 when the author signed a contract with Riggs to be his business manager (the female is unidentified). (Above courtesy of Art Seitz; below courtesy of J. J. Rayman.)

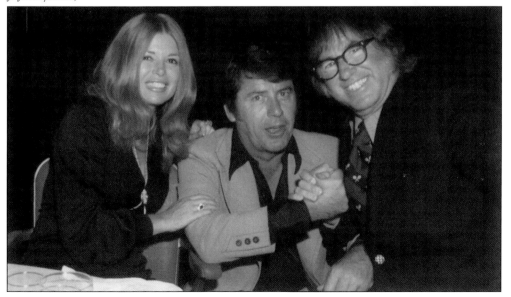

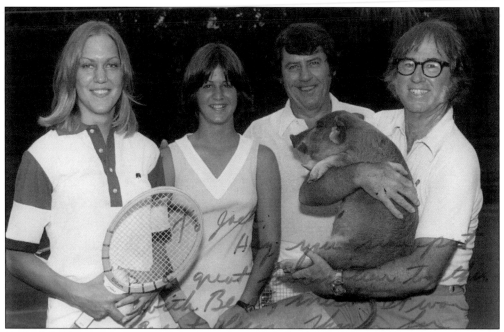

One of the first promotions the author presented to Bobby Riggs in 1975 was a campaign by Hanes Hosiery entitled "Be the Next Woman to Beat Bobby Riggs." The national promotion was extremely successful, bringing more than 2 million women into stores to sign up to be the next woman to play Riggs. The photograph above shows two female tennis players having fun with Riggs at Le Club International in Fort Lauderdale in 1975. Riggs, having the reputation of being a male chauvinist, was given a live pig by the author. The girl on the left is unidentified; pictured next is the author's daughter, Linda, then the author, and finally Riggs. Despite his reputation, most women flocked to Riggs because they knew that he was just a master promoter of himself and the game. The photograph below shows two unidentified admirers giving Riggs a kiss at a dinner at Le Club International in 1975.

Bobby Riggs was a great amateur and professional tennis player. In 1979, tennis professional Jack Kramer called Riggs the most underrated of all the top players and said that Riggs was one of the top six in the world. After taking on both Margaret Smith Court and Billie Jean King, Riggs starting doing exhibitions around the country, offering different options to his opponents. The photograph above was taken at Le Club International in 1975, where Riggs played a dozen women at a time. After defeating the 12 women, Riggs often signed autographs, took photographs with his opponents, and generally had a good time. The photograph below shows him practicing his footwork around tennis rackets. Sometimes he would bring a dog out on the court and tie the dog to his waist to give the opponents an edge. (Both courtesy of Roy Erickson.)

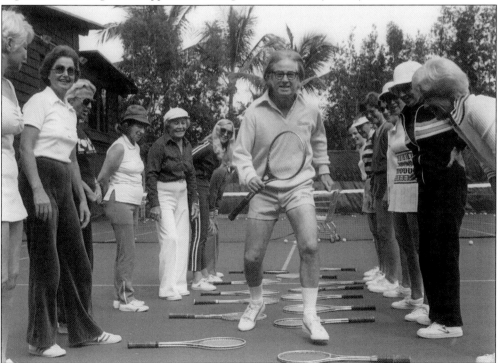

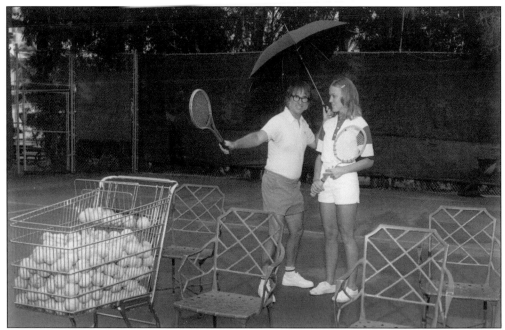

Bobby Riggs would use all kinds of things to give his opponents the feeling that they had a chance to beat him. In the photograph above, Riggs is shown with two props he often used. He would set up four to six chairs on his side of the net and play while weaving in and out of the chairs holding an open umbrella. It was entertaining to watch, and Riggs seldom lost because he always played for money. The photograph above was taken in 1974 on the courts of Le Club International with an unidentified model. Riggs spent so much time in Fort Lauderdale with the author that he made many friends and jealous enemies who lost money to him. Fort Lauderdale resident Dave Thomas, the founder of the Wendy's hamburger chain, often played golf with Riggs and used him in commercials to promote Wendy's restaurants. (Below courtesy of Roy Erickson.)

Bobby Riggs was not only a tennis hustler, but his athletic touch also allowed him to beat his opponents on the golf course. The photograph above was taken at the 1975 Jackie Gleason Inverrary Classic. Riggs loved to bet on his talents, and when he was a 21-year-old amateur, he bet on himself that he would win the Wimbledon singles, doubles, and mixed doubles titles—a triple victory. Riggs won more than $100,000 and put it in a London bank. World War II broke out, and his money was frozen for years. After all day on the golf course, Riggs often put on his tennis shirt and played a number of challengers at tennis. In the photograph below, taken in 1975, Riggs waits for his next victim.

The author was an agent for Billie Jean King and was with her at the infamous "Battle of the Sexes" match in Houston, Texas, on September 20, 1973. It was there that he met Bobby Riggs and soon after became his business manager. The author had contacts with American Express and their advertising agency, so he signed Riggs up to do some personal appearances. During these meetings, the author suggested that a reunion of King and Riggs would attract a lot of national attention. The photograph on this page was taken in 1979 in New York City at the taping of a television commercial since American Express saw the advantages of this reunion.

Six

PGA Tournament Attracts Celebrities

Most professional golf tournaments are held at golf courses that are part of a real estate development. Having professional golfers play at the site draws crowds and, in most cases, television coverage. It is a great way to get exposure to sell real estate products. In the past, many tournaments had celebrities host the event, which attracted other celebrities. Familiar names such as Bob Hope, Bing Crosby, Danny Thomas, Glen Campbell, Andy Williams, Sammy Davis Jr., and Ed McMahon hosted PGA tournaments, and even Dinah Shore acted as the host for one of the women's professional events.

In 1970, a real estate company by the name of Haft-Gaines, a division of Fuqua Industries, purchased some land west of town and called it Inverrary. The company enticed Jackie Gleason to move from Miami to Fort Lauderdale by building him an expensive home and offering to have him host a PGA tournament. This was the first men's professional golf tournament in the Fort Lauderdale area. The Jackie Gleason Inverrary Classic held its first tournament in 1972, and part of the schedule was a Wednesday celebrity pro-am tournament. The amateurs paid a fee to play with both a professional golfer and a celebrity. This day attracted thousands of people who mostly came to see the celebrities.

The developer was smart enough to make Jack Gore the first chairman. Jack was not only the editor of the *Fort Lauderdale News*, but his family also owned the newspaper. This newspaper was later purchased by the Tribune Company and is now called the *Sun-Sentinel*. Gore was a member of Coral Ridge Country Club and asked many of the club's members to volunteer to help him make this new event a success for the community and the charity. Originally, the proceeds went to the local Boys Club organization. Some members of Coral Ridge to step up and volunteer to be part of the original group included Fred Millsaps, Bill Leonard, Lou Witt, Ray Doumar, Chuck Bonura, Tom Walker, Jack Cooney, and the author.

This chapter will cover some celebrities that played in the tournament plus others who came to Fort Lauderdale to do golf exhibitions.

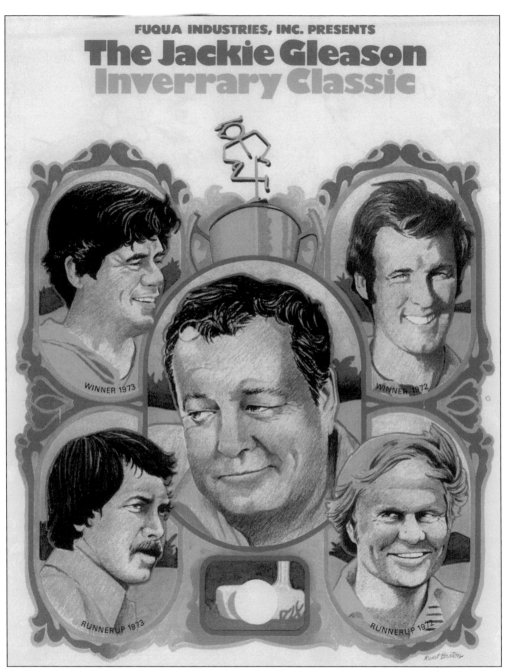

FUQUA INDUSTRIES, INC. PRESENTS
The Jackie Gleason
Inverrary Classic

WINNER 1973

WINNER 1972

RUNNERUP 1973

RUNNERUP 1972

Fort Lauderdale became the home of a nationally televised men's professional golf tournament in 1972 called the Jackie Gleason Inverrary Classic. The sponsor who brought this event to the city was Fuqua Industries and its subsidiary, Haft Gaines. In the beginning, the proceeds of the tournament were given to the Broward County Boys Club. This photograph is a copy of the cover of the program given out at the 1974 Jackie Gleason Classic, played that year from February 18 to 24. The tournament was hosted by Jackie Gleason until 1980, when the contract with Fuqua Industries ended.

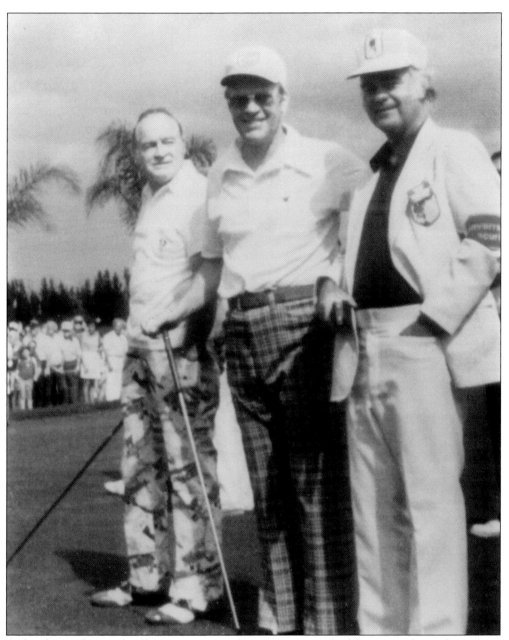

Only a few professional golf tournaments in the country invited celebrities to play in their event. With all the celebrity contacts that Jackie Gleason had, it was easy attracting big name people to Fort Lauderdale. A twosome that came frequently to play in the pro-am tournament were Bob Hope and Pres. Gerald Ford. Hope and President Ford were close friends and played golf often—mostly in Palm Springs, California. At the evening reception after the pro-am, Hope usually had fun picking on his friend with jokes like: "There are 42 golf courses in Palm Springs and nobody knows which one Ford is playing until he hits his tee shot . . . It's not hard to find Ford on a golf course—just follow the wounded . . . Jerry Ford has made golf a contact sport." This 1976 photograph shows Bob Hope (left), President Ford (center), and Lou Witt, the chairman of the Jackie Gleason Inverrary Classic. (Courtesy of *Fort Lauderdale News*.)

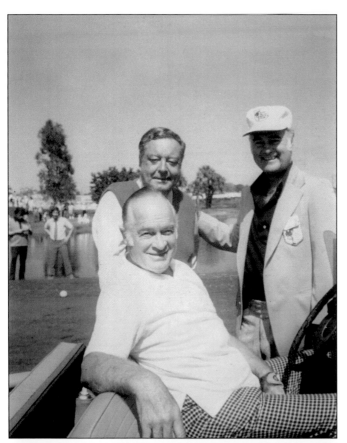

The photograph at left shows Bob Hope (seated in the cart) joining his comedian pal Jackie Gleason (center) to play in the pro-am tournament. Lou Witt, chairman of the Jackie Gleason Inverrary Classic, was their personal guide (right). Gleason moved his television show, *The Honeymooners*, to originate out of South Florida in 1964 and did his final show in 1970. The photograph below shows Witt (left) with golf legend Arnold Palmer during the pro-am reception at the Jackie Gleason Inverrary Classic in 1978. Palmer, nicknamed "The King," was and still is one of golf's most popular stars; he was the first professional golfer to earn the admiration of Americans across the country. (Both courtesy of *Fort Lauderdale News*.)

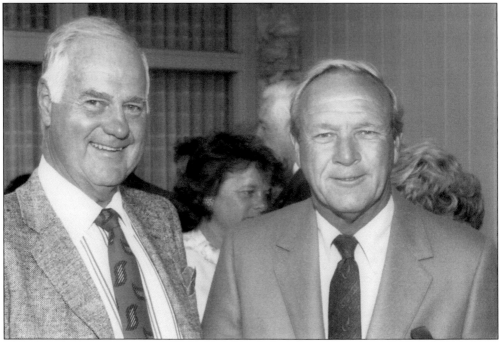

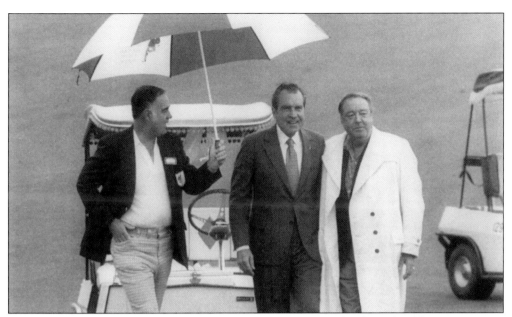

Even the rain could not keep Pres. Richard Nixon from stopping by the Jackie Gleason Inverrary Classic in 1973. The president did not play that day, but he was known to be a pretty good golfer, with a 14 handicap. The photograph above shows tournament chairman Lou Witt (with the umbrella), President Nixon, and Jackie Gleason (right) walking toward part of the thousands of people who crowded the golf course to see all the celebrities. Naturally, with all these potential voters, it was a perfect opportunity for politicians like President Nixon to shake many hands. The photograph below is proof that politicians enjoyed the Jackie Gleason Inverrary Classic with its golf, parties, and crowds. There were a number of evening cocktail parties and dinners during the week's activities. Here, at one of these affairs in 1977, is the author next to four-time governor of Ohio Jim Rhodes and Betty Ford with President Ford. The lady on the right is unidentified. (Above courtesy of *Fort Lauderdale News*.)

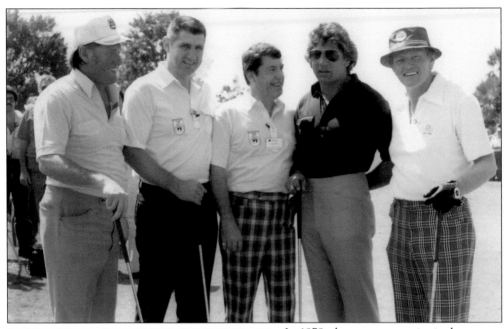

THANKS FOR THE MEMORY

DOLORES AND FAMILY

In 1978, the tournament invited a number of football's greatest quarterbacks to attract crowds who might not like golf but were football fans. Top quarterbacks such as Johnny Unitas and Bob Griese gave their time to raise money for the Broward County Boys Club. Pictured above, from left to right, are Billy Kilmer, Earl Morrall, the author, Joe Namath, and Sonny Jurgensen. The photograph at left is a classic shot of Bob Hope wearing one of his many hats. This one was a tribute to Ben Hogan, who often wore this style of hat. The photograph was taken in 1979, the last year Hope played in the Jackie Gleason Inverrary Classic. In 1980, the tournament committee lost the sponsorship of Fuqua Industries and the participation of Jackie Gleason as host. American Honda became the new sponsor.

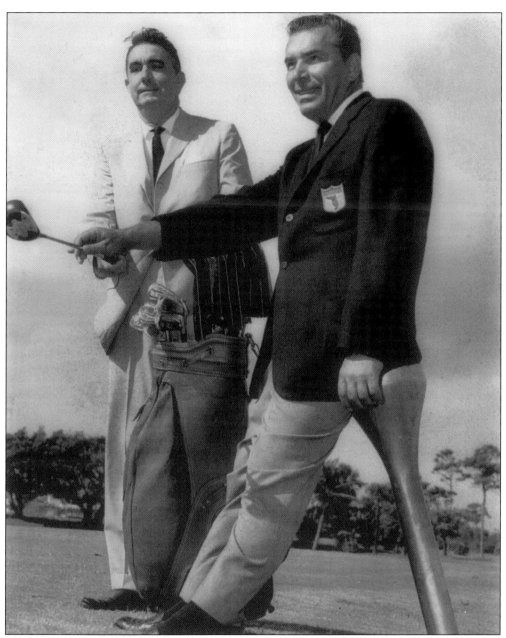

Another great athlete that lived full-time in Fort Lauderdale was professional golfer Julius Boros. Boros, his wife, Armen, and their large family lived right off the ninth green at the Coral Ridge Country Club. Although Boros turned professional late in life, he still won 18 PGA events, including three major championships, the 1952 and 1963 U.S. Opens and the 1968 PGA Championship. In 1968, Boros was the oldest player to ever win a major championship at the age of 48. This promotional photograph was arranged by the author in October 1963 at the Coral Ridge Country Club to publicize Boros being named Golfer of the Year. The mayor of Fort Lauderdale, Cy Young, is on the left. In March 1994, at the age of 74, Boros was found by the author lying on the ground near the 16th hole at Coral Ridge, having succumbed to a heart attack. (Courtesy of UPI Telephoto.)

The author convinced his client Eastern Airlines to underwrite an 18-hole exhibition match in March 1968 at the Coral Ridge Country Club. The author knew if he could book the most identifiable golfer in the game, Arnold Palmer, the day would be a success for the local Boys Club. After signing Palmer, the author booked Sam Snead as the other professional golfer and got commitments from Perry Como and television star Chuck Conners. The photograph above shows the group lining up for a publicity shot before the match. Pictured from left to right are the author, Palmer, Como (with his hands on the shoulder of an unidentified boy), Conners (towering over the head of Como), local banker Harry Greep, and Snead. Pictured below, from left to right, are the author, a shy, unidentified member of the local Boys Club, Conners, Palmer, and Snead hidden behind Como.

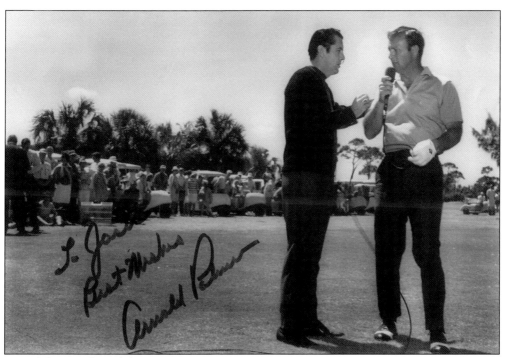

Part of the one-day exhibition matches was a clinic given by Arnold Palmer. The photograph above shows the author explaining to Palmer some details of the day. During his career on the PGA Tour, Palmer won every possible tournament, including the Masters four times. Palmer and Chuck Conners beat the team of Perry Como and Sam Snead, and everyone had a great time. The image below is a copy of the letter sent to the author by Conners after he left Florida to return to California. Conners always wanted to be a professional athlete, and he achieved that goal by being one of only a few athletes in history to have played professionally in two sports, the baseball major leagues and as part of the NBA with the Boston Celtics.

CHUCK CONNORS

April 3, 1968

Jack Drury Associates, Inc.
Mr. Jack Drury
2801 East Oakland Park Boulevard
Fort Lauderdale, Florida

Dear Jack:

Thank you so much for your letter and the photo-
graphs you sent me. I should have known I could
count on you, and I certainly will plan on getting
in touch with you the next time I'm in Florida.

Thanks again.

Sincerely,

Chuck Connors

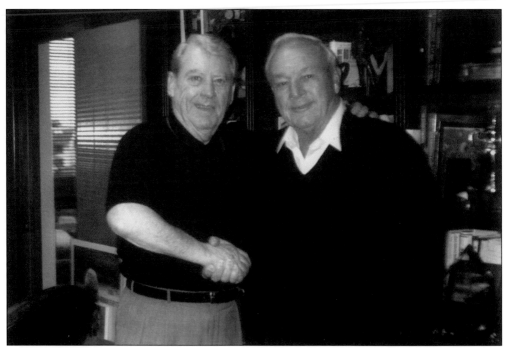

arn ld palmer

*post
office
box
fifty-two
youngstown,
pennsylvania
15696*

July 13, 1999

Dear Jack:

It was certainly nice to hear from you again after
all these years and to look at the photographs you
sent along for me to see and autograph for you.

As in the 60s, you are again supporting most worthy
causes and I would certainly like to be able to
participate. Unfortunately, my schedule is already
too far advanced and other factors weigh too heavily
for me to be able to consider your request.

I trust that you will understand these circumstances
and proceed along other avenues to a highly success-
ful result at the end. Good luck.

Sincerely,

Arnold

AP:gwv

Mr. Jack Drury
Jack Drury & Associates Inc.
P.O. Box 11385
Fort Lauderdale, FL 33339-1385

The author remained friends with Arnold Palmer after the exhibition match in Fort Lauderdale in 1968, joining him often at the Bob Hope Chrysler Classic in Palm Springs. Palmer hardly ever missed playing in the Hope Classic because of his deep affection and friendship with Bob Hope. In 1999, the author met with Palmer at his Bay Hill golf club in Orlando, Florida, to ask him to serve on the advisory board for Wheelchair Foundation, which he agreed to do. During that meeting, the author asked him to do another clinic in Fort Lauderdale, but Palmer could not fit into his already busy schedule. The image below is a copy of that letter.

Seven

CELEBRITY TENNIS COMES TO FORT LAUDERDALE

Two great promoters were Paul and Lambert Holm, who in 1969 took a small, broken-down building called the Everglades Club, located one block south of Sunrise Boulevard on the east side of the Intracoastal Waterway, and turned it into an exciting, thriving hangout for swingers, politicians, and celebrities, renaming it Le Club International. Those that never witnessed the era of Le Club International need to understand what the club offered to its members and visitors. After minor alterations from the Everglades Club, Le Club International had one small pool that a swimmer could dive in and reach the other end before coming up for air. It had two tennis courts and about a dozen hotel rooms. The bar area, which overlooked the pool, could handle 30 people at most. The dining room had a small portable stage so low to the floor it did even not need stairs.

But within this tiny facility, the Holm brothers created all kinds of excitement, and somehow arranged to have top-name talent performing on that mini-stage, including Dinah Shore, Ed Ames, Burt Bachrach, the McQuire Sisters, and more. All performed without being paid a penny. It was the place to go to have fun, eat great food, and rub elbows with the likes of Johnny Carson, Ed McMahon, Joe Namath, Dina Merill, and George Peppard.

The Holm brothers somehow convinced television star Dinah Shore to fly all the way from California to Fort Lauderdale to host the first Le Club Celebrity Tennis Classic in 1971. During the next few years, other top Hollywood stars such as Charlton Heston and George Peppard were hosts, and they invited their pals like Clint Eastwood, Phyllis Diller, Burt Bacharach, Hugh O'Brien, and tennis professionals like Billie Jean King, Bobby Riggs, and Rod Laver to be part of the fun. No tennis events like this ever happened in Fort Lauderdale after the Holms sold the club in 1979; the era ended.

The author, who was one of the original members of Le Club International, wants to thank Paul and Lambert Holm for their creativity and promotional skills in making those 10 years a real "Playground for the Stars."

Those people who were lucky enough to be members of Le Club International or who had a way of getting one of the limited number of spectator tickets could enjoy watching tennis, eating great food, and enjoying the star atmosphere of the club. The photograph above shows Le Club International co-owner Lambert Holm in 1973 with host Charlton Heston. Most people remember Heston as Moses in the movie *The Ten Commandments*, but he has appeared in more than 100 films since his big break in 1950 as Mark Anthony in the movie *Julius Caesar*. Heston received an Academy Award in 1959 for Best Actor for the movie *Ben Hur*. The photograph below shows emcee Lambert Holm (right) introducing the next entertainer to the mini-stage at Le Club International. In 1974, Alan King came to Fort Lauderdale from his home in New York City to be a part of the fun. King was one of the country's busiest comedians, appearing many times on late night shows such as Johnny Carson's *Tonight Show*. (Both courtesy of Lambert Holm.)

Please don't laugh too hard, but that is the author in the right photograph on the dance floor at Le Club International in 1971 dancing with the host of the tennis classic, 55-year-old Dinah Shore. At this time in her long career, Shore also hosted not one but two daytime television shows, *Dinah's Place* and later *Dinah and Friends*. Primarily known as a singer, Shore also appeared in 15 films. She never asked the author to dance again. The photograph below is one of the author's favorites; he is standing next to actor Clint Eastwood, a man the author admires greatly. Eastwood portrayed hard-edged police inspector Harry Callahan in the highly acclaimed movie *Dirty Harry,* which enjoyed box office success in four sequels. (Right courtesy of Ray Fenn.)

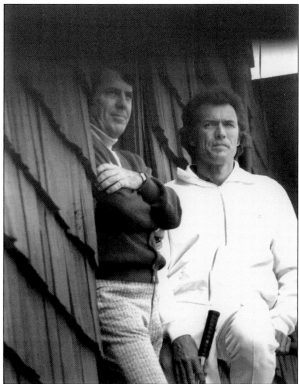

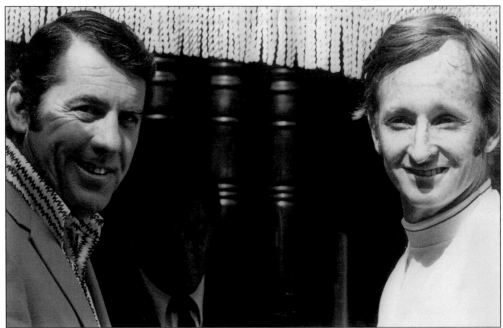

In the photograph above, the author is with one of the all-time tennis greats, Rod Laver, who came to the celebrity tennis classic at Le Club International in 1973. Australian born Laver started his professional career in 1962 and retired in 1979 after winning more than one-half million dollars and having been ranked No. 1 in the world in 1968 and 1969. The photograph below shows Frank Gorshin at Le Club International with the author in 1974. Gorshin was another versatile actor and performer, appearing on stage, in film, and on television. He was also one of the actors in the 1960 film shot in Fort Lauderdale entitled *Where the Boys Are*. (Below courtesy of Roy Erickson.)

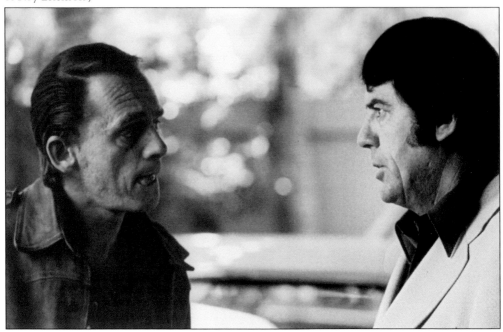

The photograph above shows a smiling Phyllis Diller coming off the court for a rest in between sets. This great comedian created the character of a wild haired, eccentrically dressed housewife who made jokes about her husband named "Fang," which incidentally was the nickname of her first husband, whom she divorced. This mother of five was also known for her distinctive, crackling laugh and appeared regularly as a special guest on many television programs, including many Bob Hope specials and on Rowan and Martin's *Laugh-In* series. One of the biggest hits from 1973 to 1978, when these celebrity tennis tournaments were held in Fort Lauderdale, was the television series *Kojak*. The photograph below shows the star of that series, Telly Savalas, without his famous lollypop or a tennis racket. He often entertained the audience as a tough lineman, making many questionable line calls. No one ever won an argument with Savalas. (Both courtesy of Arnie Milton.)

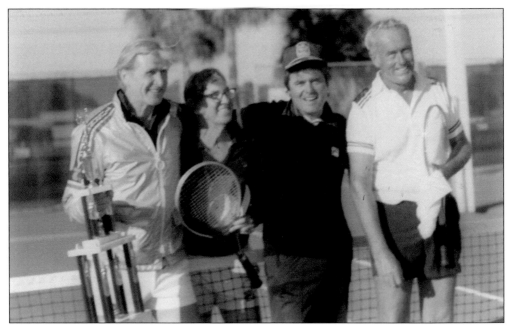

The photograph above shows several other top stars. Lloyd Bridges (left) was a television and motion picture star with a long and impressive career that brought him to Florida frequently. Actress and model Wendy Wagner, pictured on the cover, appeared in a television series filmed in Florida from 1957 to 1961 called *Sea Hunt* that starred Bridges. Tennis hustler Bobby Riggs (second from left) is standing next to Mike Douglas, the host of the Mike Douglas Show, a top-rated syndicated television show appearing in close to 200 markets. The man to the far right is unidentified. Someone else who was attractive to the female set was Pat Boone, shown in the photograph below. Born in Florida, Boone was no stranger to the state and incidentally was a direct descendant of the American pioneer Daniel Boone. (Both courtesy of Arnie Milton.)

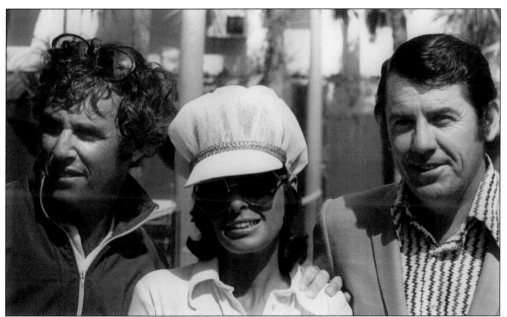

Burt Bacharach was another celebrity that attracted women of all ages to come to Le Club International to see him play in the 1973 Le Club International Tennis Classic. The award-winning pianist and composer is best known for the pop hits he wrote with Hal David from 1962 to 1970, so when he visited Fort Lauderdale, he was at the peak of his career. The men, including the author, were disappointed that Bacharach did not bring his wife, Angie Dickinson, to the tournament. The photograph above has Bacharach with local housewife and volunteer Mitzi Doumar and the author. The photograph below shows George Peppard, the host of the 1973 Le Club International Celebrity Tennis Classic. Peppard was an acclaimed actor in both movies and television, but it was his role alongside Audrey Hepburn in the 1961 movie *Breakfast at Tiffany's* that kicked off his career. During the years he participated at Le Club International, he was staring in the highly successful television series *Banacek*. (Both courtesy of Arnie Milton.)

The photograph above shows Bobby Riggs in 1974 at Le Club International participating not just as a former tennis professional, but also a celebrity. After Billie Jean King trounced Riggs in the Houston, Texas, "Battle of the Sexes" match on September 20, 1973, (6-4, 6-3, 6-3), he continued his male chauvinist role (for more on Riggs and King, see Chapter Five) and was one of the many celebrities that found a home in Fort Lauderdale. The photograph below shows Dan Rowan of the famous comedy team of Rowan and Martin. After Rowan retired from entertaining, he moved to Florida. Starting out as a writer at Paramount Studios in Los Angeles, he teamed up with Dick Martin and started a nightclub act, but the team's biggest success came in 1967 when he and Martin found fame on the clever *Laugh-In* television show. (Both courtesy of Arnie Milton.)

Le Club International's activities, such as the tennis classic, also included boat races, hot-air balloon races, backgammon tournaments, and more, all of which attracted both locals and celebrities. The photograph above is one taken in 1975 at Le Club International with the center of attention being football quarterback Joe Namath. Pictured with Namath (from left to right) are Dr. Bob Helmholdt, Jan Collinan, the author, and Sherrill Capi, all enjoying one of the newest celebrities to move to Fort Lauderdale. Another well-known person to buy a home in Fort Lauderdale was Evel Knievel, who, of course, found his way to Le Club International. The 1979 photograph below was taken during one of the balloon races sponsored by the club. Knievel had agreed to let people roast him at a fund-raising dinner, and the photograph was taken when it was the author's turn to rib Knievel about his unsuccessful attempt to jump over the Snake River Canyon in 1974. (Both courtesy of Plummers Photos.)

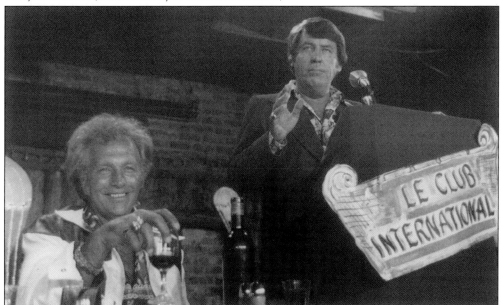

The final photograph of this chapter is a celebrity that most readers will not remember, but he was a major entertainer in his day, mostly on the radio in the 1930s and 1940s—just ask your grandparents. This 1964 photograph was taken at the Lago Mar Hotel, where the author arranged for a free suite for Rudy Vallee and his wife (Marie Drury and the author are on the left). After a free week, Vallee told the author that if he ever got to New York, please come see his hit Broadway show *How to Succeed in Business*. A few months later, the author, his wife, and another couple flew to New York and called Vallee for four tickets. When the author met Vallee at the stage door to pick up his tickets, Vallee pulled out a little purse and said "that will be $22.50 each please." This naturally caught the author by a total surprise, but when the author told his friend Johnny Carson the story, Carson said he heard that Vallee even had a pay phone installed in his house for guests to use. (Courtesy of J. J. Rayman.)

Eight

CELEBRITY GRAND MARSHALS OF THE BOAT PARADE

Those who have lived in Fort Lauderdale for 40 years or more often are asked if they miss the change of seasons, and some do, but the author has always admired the ingenuity of the residents of Fort Lauderdale for creating other ways to enjoy the seasons. In 1971, a group decided to decorate 20 boats with Christmas lights and ornaments, and the revelers motored up and down the waterways singing Christmas carols. From that wonderful original group, a non-profit organization was created in 1987 called Winterfest, and now this boat parade is the largest single-day festival in the country, with more than 1 million people lining up to view the parade. It usually takes place on a Saturday evening in mid to late December, and those who own restaurants, condos, or homes that overlook the route of the parade throw parties and turn the evening into a major holiday event.

The Winterfest Boat Parade in 2004 attracted a sponsor, the Seminole Hard Rock Hotel and Casino, to help make the event even bigger and better. Locals in Fort Lauderdale are proud to have such an international event as the town's way to celebrate the holidays. This chapter will cover some of the celebrities who were grand marshals for the parade. All pictures are courtesy of Winterfest.

When the parade got the attention of the country, it also got the attention of Willard Scott, the famed meteorologist of the *Today Show* on NBC. Scott was the first grand marshal of the boat parade and sent live reports of the wonders of the Fort Lauderdale festival to television viewers all over the country. This photograph of Scott with Ina Lee, the president and chief executive officer of Winterfest for seven years, was taken on the beach during a live interview on the *Today Show*. Winterfest and Scott continued their love affair for the next four years.

Bob Hope made the cover of the local magazine in December 1987 because he decided to bring his crew of 60 people from California to tape his 1987 Bob Hope Christmas Show from Fort Lauderdale featuring the Winterfest Boat Parade. The one-hour NBC special used a number of local sites for various segments. Every year during Hope's Christmas specials, he would introduce the college All-American football team, so Hope selected the football field at Pine Crest High School for that part of the show. The producer also closed down Las Olas Boulevard in front of the Riverside Hotel and turned the street into a winter wonderland for Hope's duet with Reba McEntire, entitled "Silver Bells." Other segments were taped at the beach near the famous Elbo Room, at the Sunrise Musical Theatre, and on the Intracoastal Waterway near the former Marriott Marina, now called the Fort Lauderdale Grande Hotel off of Seventeenth Street Causeway.

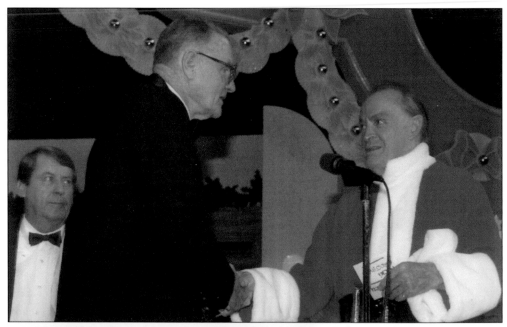

Bob Hope played Santa Claus in a couple of the segments of the 1987 Bob Hope Christmas television special aired on NBC, December 19, 1987. The photograph above was taken after the taping on the stage at the Sunrise Musical Theatre on December 8, 1987. During Hope's monologues, he told the audience about the Winterfest Boat Parade and that the mayor's boat had dancing girls, loud music, and non-stop booze, and with that for an introduction, Mayor Bob Cox leaped up on stage. The photograph below shows Ina Lee, who was the chairman and chief executive officer of Winterfest, giving Hope a gift from her committee. Lee was instrumental in negotiating for the grant to cover the expenses for the six days of taping. The grant was certainly worth it, since an estimated 30 million people tuned in to watch the Hope Christmas show featuring Fort Lauderdale. (Both courtesy of John Pearce.)

In 1991, the Winterfest Boat Parade selected television personality Joan Rivers as the grand marshal. In the photograph above, volunteers Joe Millsaps (left) and Charlie Folds escort Rivers to the reception where she entertained the volunteers and sponsors. The photograph below shows television personality Ed McMahon surrounded by Mickey Mouse and Minnie Mouse, all of whom were grand marshals for the 1992 Winterfest Boat Parade, which sailed up the Intracoastal Waterway on Saturday, December 19, 1992. The authorities said that the audience that viewed this parade swelled to more that 700,000 that year.

The Winterfest Boat Parade committee, guided by its public relations specialists, made a wise decision in 1993 by offering the title of grand marshal to one of television's hottest properties—Regis Philbin (pictured at left). His nationally syndicated television show, at that time called *Live with Regis and Kathie Lee*, had a huge nationwide audience that viewed footage from the boat parade for seven minutes the Monday after the parade. Philbin and Winterfest were so happy with their marriage that he returned to be grand marshal again in 1994. The photograph below shows Philbin being greeted by committee member Phil Goldfarb.

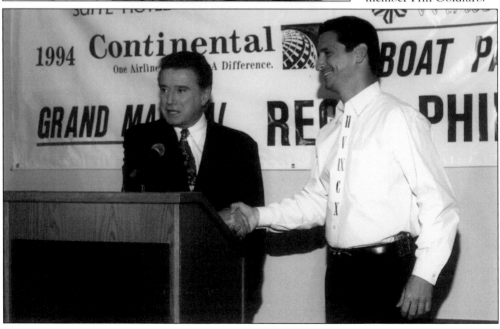

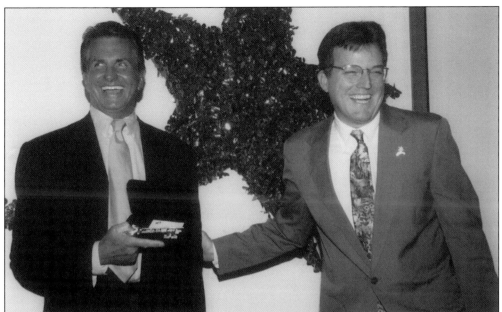

The women on the Winterfest Boat Parade committee definitely made their influence felt by offering the title of grand marshal of the 1995 parade to handsome movie star George Hamilton, shown in the photograph above with Mayor Jim Naugle. Fort Lauderdale was no strange place to Hamilton—he was raised just up the road in Palm Beach. The photograph at right shows Hamilton taking questions from the press about the most famous movie to ever be made in Fort Lauderdale, the 1960 film *Where the Boys Are*, which was about college spring break. Hamilton was the male lead, and the cast included Connie Frances, Paula Prentis, and hundreds of Fort Lauderdale kids who were used as extras on the beach as a background for the movie. *Where the Boys Are* premiered at the Gateway Theatre on Sunrise Boulevard on December 21, 1960. See page 114 for a photograph taken of Hamilton in Fort Lauderdale in 1963—the man does not age!

This book is about all kinds of celebrities. These talented people can come from all walks of life. One of the most visible and likable of Fort Lauderdale's residents was certainly a celebrity because of his national exposure as the spokesperson for the company he founded—Dave Thomas, chairman and founder of Wendy's Old Fashioned Hamburgers. Joining Thomas in the photograph above in the role as grand marshal for the 1997 Winterfest Boat Parade was then–Miss USA Brandi Sherwood. In 1998, the acclaimed movie actress and singer Ann Jillian led the boat parade as it celebrated its 27th anniversary. The photograph below shows Jillian flanked by Winterfest president and chief executive officer Lisa Scott Founds (left) and longtime volunteer and local advertising guru John Forsyth. Jillian had appeared in films and on television since her career started in 1961, when she appeared in the Disney film *Little Bo Peep*.

Named the 20th Best Parade in the World by the International Festival and Events Association, Winterfest selected a grand marshal that would not only appeal to the youth but also to the ever-growing Hispanic population in South Florida, as well as give the parade an international touch. The photograph at right has the 1999 grand marshal, Julio Iglesias Jr., with Winterfest president and chief executive officer Lisa Scott Founds. In 2001, the Winterfest committee enticed one of the country's most well known businessmen to add his name to the event, and he must have enjoyed Fort Lauderdale, because soon after, he announced he was going to build a new hotel on the beach. The photograph below has 2001 grand marshal Donald Trump with (from left to right) Miss Florida Shannon Ford, Trump, Melenia Krauss, and Florida's Miss Teen, Ashlee Cuza.

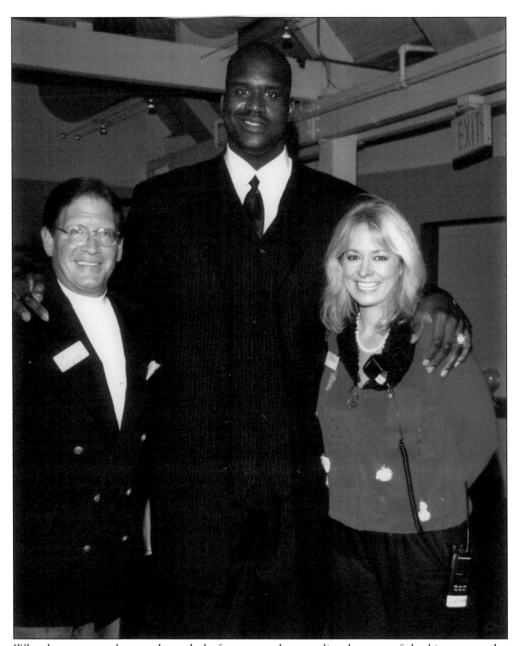

Who do you get to be grand marshal of an event that was listed as one of the biggest one-day festivals in America in 2004? Why, of course, you get the biggest person to ever hit South Florida, basketball great Shaquille O'Neal. The "Shaq Attack" joined the Miami Heat basketball team in July 2004; in 2006, Shaq helped produce a NBA championship as promised. In the photograph, O'Neal, at 7 feet 1 inch tall, towers over David Founds (left) and Lisa Scott Founds, the president and chief executive officer of Winterfest. Other grand marshals not pictured in this chapter include Cathy Lee Crosby, Lee Majors, Kelly Ripa, Mark Consuelos, David Cassidy, Randy Jackson, Frankie Vallee, and Lorraine Bracco. The author joins all the residents of Broward County in a salute to the leadership of people like Ina Lee and Lisa Scott Founds and all the sponsors, volunteers, and staff of Winterfest for making this a great community event.

Nine

IT'S HOWDY DOODY TIME

"It's Howdy Doody Time." Those were the words said by "Buffalo Bob" Smith thousands of times at the beginning of the NBC children's show *Howdy Doody* from December 1949 to 1960. The *Howdy Doody* television show was the No. 1 children's show for years, winning many awards. It was so powerful that, for fun, Howdy ran for "President of all the kids in America" in 1949, and Howdy won easily over all other candidates. It was an awesome example of the popularity of the show.

Bob Smith, voted one of the 10 outstanding legends of television, grew up in Buffalo, New York, and created a character called Howdy Doody during his days on the radio. He was the voice of Howdy, so when he went on television, he had to pre-record Howdy's voice, and it was arranged perfectly for Smith to talk and have Howdy answer. This was very difficult since the show was live.

Smith moved to Fort Lauderdale in 1968, invested in many real estate projects, and played golf often at the Coral Ridge Country Club. In 1971, Smith signed the author to be his business manager, and it was not long before Smith was back performing again. He went on a tour, appearing at colleges and shopping malls with "Clarabell the Clown," attracting young adults who grew up watching the original shows. Smith's return from retirement created so much attention that he appeared as a guest on blockbuster network television shows such as *Laugh-In*, *Happy Days*, Andy Williams and Glen Campbell specials, and, of course, the *Tonight Show* with Johnny Carson.

All this excitement resulted in the author negotiating an agreement with NBC to put Smith back on television with the *New Howdy Doody Show*. All 130 half-hour shows were taped in 1976–1977 in a studio located just south of Fort Lauderdale. The taping of these 130 shows brought revenue to the area with the hiring of 30 or more people, including the author's son, Chris, who worked for six months taping the shows, which went into syndication all across the nation. Every show plugged Florida and continued to give positive messages like: "Be kind to animals," "Save your pennies," and "You don't cross the street with your feet; you cross with your eyes."

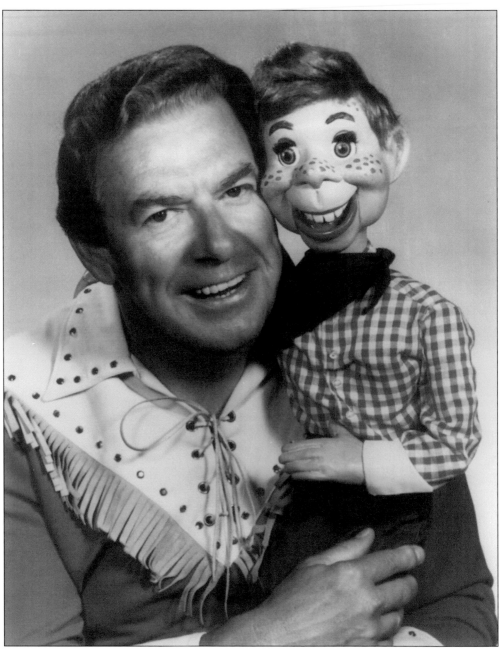

Before the tapings of the *New Howdy Doody Show*, an updated photograph was taken of Buffalo Bob Smith and Howdy Doody for publicity purposes. Like most of us when we get older, his hair gets gray, so in 1976, Smith, who was 58, decided to darken his hair for the tapings. Even Howdy Doody got a new look.

Berry's World

© 1976 by NEA, Inc.

"I didn't realize the return of The Howdy Doody Show would hit you so hard!"

The *New Howdy Doody Show* had such an impact on the American public that the famous cartoonist Jim Berry drew this cartoon, which appeared in hundreds of newspapers across the country. The cartoon says it all. The adults who watched Howdy as a child, along with their children, were the target audience of the new television series. (Courtesy of NEA, Inc.)

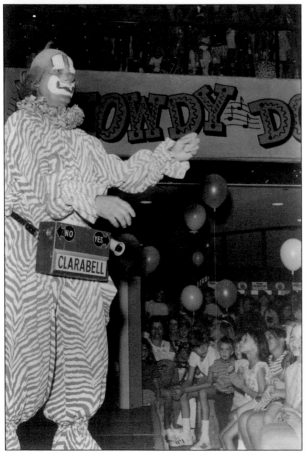

The shows were taped for six months in 1976–1977 before a live audience in a studio just south of Fort Lauderdale, and of course, the producer wanted a "Peanut Gallery" like they had in the original shows. The audience was comprised of adults who grew up watching the original show, which aired from 1949 to 1960, when they were kids in the "Peanut Gallery," and their children. The photograph above shows Clarabell the Clown kidding with the mixed audience comprised of mostly adults, including the author's wife and daughter in the front row (left). The photograph at left shows one of the most loved characters on the original *Howdy Doody Show*, who also appeared in the new shows taped in 1976: Clarabell the Clown entertains children at a mall in Fort Lauderdale in 1979. The first person to play Clarabell, was Bob Keeshan who later was Captain Kangaroo. Lew Anderson took over the character and was Clarabell from 1952.

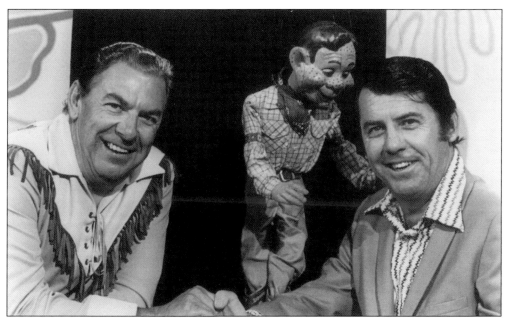

The press coverage of Buffalo Bob Smith and Howdy Doody returning to television generated such excitement that one of the most popular shows of the time, *Laugh In*, asked Smith to appear. The photograph above was taken in 1977 at the Burbank Studios where *Laugh-In* was taped for NBC. When the author flew out to meet Smith in California, he took Howdy in a special box on the airplane. It did not fit under the seat, so the pilot, being a big fan of the show, took Howdy up front to the cabin to ride with him. The guest cohost of the show, Dick Martin, is shown in the photograph below with Howdy during a skit on the *Laugh-In* set in Burbank, California, in 1977. One of the skits taped on the show included Martin trying convince Howdy to leave Buffalo Bob and join *Laugh-In*. (Above courtesy of Mike Sheldon.)

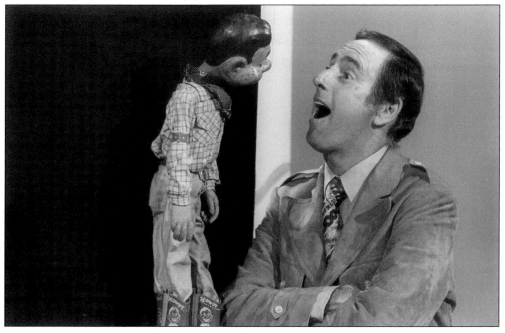

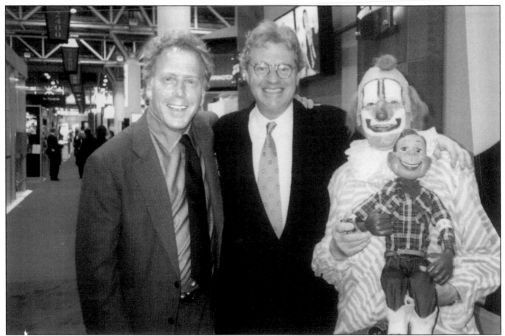

Bob Smith was so admired by his peers that he was accepted and recognized as a true professional entertainer whenever he appeared as a guest on other shows. Pictured above while at a convention are Burt Duprow (left), Jerry Springer (center), and Lew Anderson, who played Clarabell the Clown. Pat Sajak, the host of the long lasting and successful *Wheel of Fortune* television series, is still a big fan of the *Howdy Doody Show* and took the time to pose for the photograph below with Clarabell the Clown at the same convention. Clarabell is holding what Smith called "Photo Doody." This was a Howdy Doody doll without strings so it could be positioned various ways for photographs and was much easier to use during personal appearances.

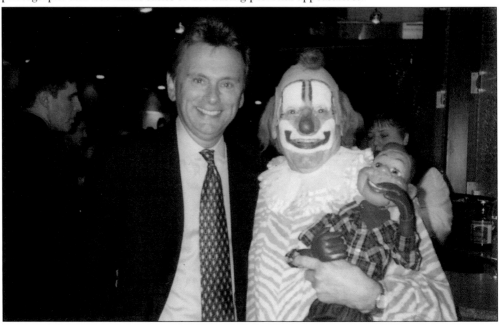

The author is shown in this photograph (right) at a 1997 press conference in Fort Lauderdale with Clarabell the Clown. The reason that Clarabell did not talk on the shows was because when the character was introduced on the original show in 1951, the producers did not want him to say anything because they would have to pay him extra money. On the last show of the original series on September 24, 1960, Clarabell finally talked, saying "Good-bye kids," and many children in America cried because the show they loved was going off the air. Bob Smith loved to play golf and is shown in the photograph below with the author and Don Soffer (right) at a golf tournament at the Coral Ridge Country Club in 1986. Smith survived two major heart attacks during his career and tried to exercise as much as he could, with golf being one of his hobbies.

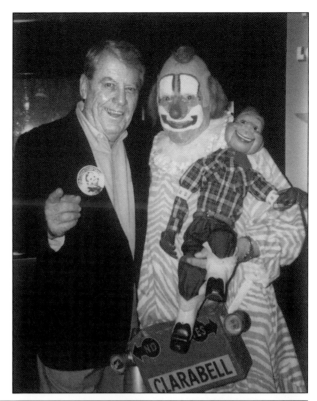

Bob Smith and the author were in New York in 1998 promoting the videos of the *New Howdy Doody Show* and celebrating the 50th anniversary of Howdy Doody. Smith did three or four media interviews every day on this two-day trip and was always available to sign autographs. This was the last photograph taken of Smith with the author. Smith died in July of that year at the age of 80.

Ten

THE PLACE FOR
THE STARS

As Fort Lauderdale grew, more and more celebrities decided to live and vacation in the area, including baseball's Whitey Ford and Carl Yastrzemski; football stars Billy Kilmer, Joe Namath, and Earl Morrall; tennis great Bobby Riggs, who bought a motel and a bowling alley; and Johnny Carson, who was one of the first to purchase land in Coral Springs.

Celebrities have their own network of communication, because once the world considers a person a celebrity, that person has similar problems and blessings. They no longer have a private life; people want autographs and photographs, and the entertainment press never stops bothering them. They talk to each other about places to go where they can relax. In the 1960s and 1970s, Fort Lauderdale was one of those places where celebrities came for vacation, fun, and work. Many top advertising agencies in New York and Chicago, for instance, used Fort Lauderdale as a location for television commercials since it offered not only the ocean, beaches, and waterways, but many other options. The large oak trees around the old Rolling Hills Country Club in Davie had a northern look. Birth State Park and the Bonnett House off of Sunrise Boulevard were often used because of what they offered the camera. This chapter will cover a number of celebrities who came to Fort Lauderdale to appear in commercials, make personal appearances, or just vacation.

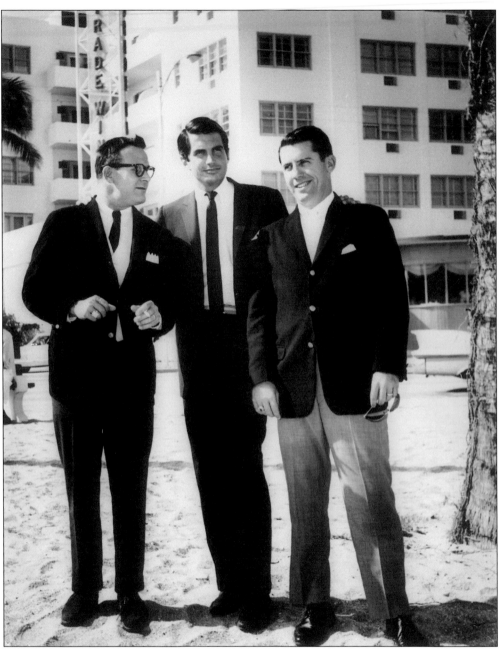

After the full-length movie *Where the Boys Are*, filmed entirely in Fort Lauderdale in 1960, was seen by America, the influx of college students increased, and the star of the film, George Hamilton, was well known in Fort Lauderdale. In this 1963 photograph, Hamilton (center) visits Fort Lauderdale to promote his latest films, *The Victors* and *Act One*. He was interviewed by the entertainment editor of the *Fort Lauderdale News*, Dick Hoekstra (left). The author is on right. It was decided to take a photograph on the beach in front of the Tradewinds Hotel, which was just a few blocks north of the Elbo Room on Las Olas Boulevard, where many of the scenes were filmed for *Where the Boys Are*.

114

During the 1960s and part of the 1970s, the Fort Lauderdale hotels had great nightly entertainment, with acts like local favorite Woody Woodbury packing them in at the Bahamas Hotel. Bob Gill, owner of four hotels, brought in musical and comedy acts from Las Vegas, Nevada, to appear in the lounges at the Yankee Clipper, Jolly Roger, Escape, and Tradewinds Hotels. It was like a mini Las Vegas strip. People would plan an entire evening with drinks, dinner, and catch a late show, all within the confines of the beach from Oakland Park Boulevard to the Seventeenth Street Causeway. This photograph was taken at the Tradewinds Hotel in 1963, when actor Vincent Price came to Fort Lauderdale to promote his latest movie, *Beach Party*. Price was best known for all the horror films he appeared in and for being a regular guest on the television show *Hollywood Squares*.

In 1961 and 1962, the author frequently traveled to New York City on business, and on one trip he met Robert Ruark, the journalist, traveler, and author of many best selling books. Ruark was told by his publisher that the manuscript he was working on, called *Uhuru*, was hundreds of pages too long and had to be condensed. So the author seized the opportunity and told Ruark he had a nice quiet place to work, inviting him to stay at the Escape Hotel, which was a few blocks off the beach and secluded. Ruark came to Fort Lauderdale in 1962 to work on *Uhuru*. The author had the telephone removed from his room and left word that no one was to bother him. This photograph shows Ruark (center) in his tuxedo while hosting a party to celebrate finishing the book. The author is on the left, and the woman is unidentified.

In the 1960s, one of the author's clients was a new university called Nova, and at that time, it was more of a concept than a reality. But at Nova High School, they were doing some newsworthy things, so the author approached a young writer/researcher at NBC's *Today Show* with the suggestion of visiting Fort Lauderdale to see it for herself. Her name was Barbara Walters, and the 1965 photograph above shows Walters (left) with three unidentified students and the author (right) participating in a student-led interview. The taped segment of her visit to Fort Lauderdale ran for five minutes on the *Today Show*, and it was not long before Walters moved up to become the show's first female cohost. Walters is also the host of the popular daytime talk show *The View*. The image at right is a copy of a note to the author from Walters after he sent her an article that appeared in the June 6, 1965, issue of the *Miami Herald*.

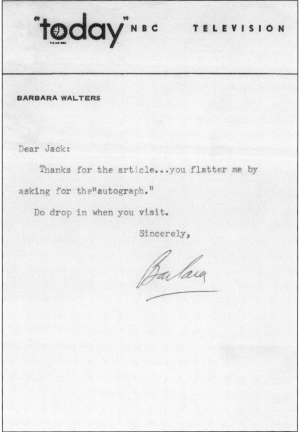

"today" NBC TELEVISION

BARBARA WALTERS

Dear Jack:

Thanks for the article...you flatter me by asking for the "autograph."

Do drop in when you visit.

Sincerely,

Barbara

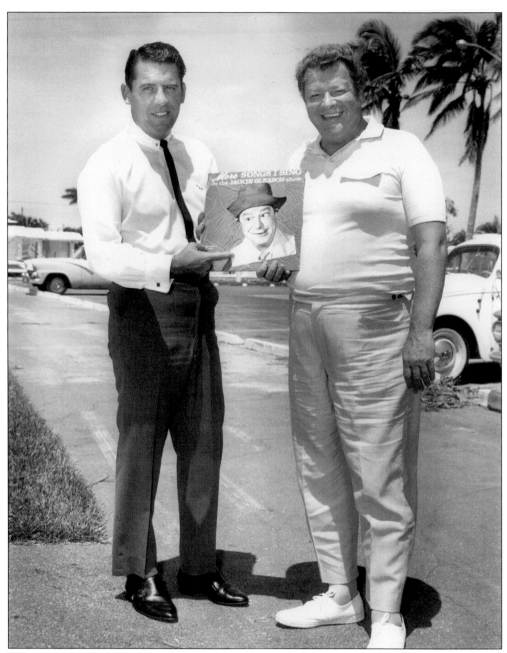

"How sweet it is," or was in 1964 when Jackie Gleason decided to leave New York City and move his production team to Miami Beach to do his television shows. For six years, Gleason and his talented performers originated from South Florida, entertaining America with *The Honeymooners* and the Jackie Gleason variety specials. One of the characters on the Gleason show was "Crazy Guggenheim," played by Frank Fontaine, who would sing sentimental ballads on the shows. Fontaine preferred to live in Fort Lauderdale instead of Miami, so he and the author became friends. This photograph was taken after a luncheon in 1965 to promote Fontaine's newest album, *More Songs I Sing on the Jackie Gleason Show*. Fontaine was 44 years old when this photograph was taken, and unfortunately, he died of a heart attack at the young age of 58.

The photograph at right was taken in 1968 at a press party at the Bachelors III restaurant on Sunrise Boulevard, where Joe Namath was a partner. Namath (left) poses with reporters Pat Brown and Crickett Matthews. Namath had already become a star in football circles, being voted to the All-Star team in 1965, 1967, and 1968. Namath knew how to promote himself, and he signed with the New York Jets in 1965 for a salary of $400,000, a record in professional football at the time. The author and Namath became friends, and the author arranged to get an apartment for him near the Coral Ridge Country Club. The photograph below is Bobby Riggs during a television commercial for the local franchise of Wendy's hamburgers, co-owned by former tax assessor Bill Markham and Ken Thomas, the son of the founder and chairman of the Wendy's chain, local resident Dave Thomas.

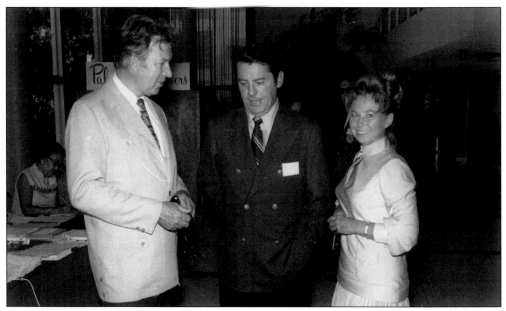

Fort Lauderdale resident Herb Shriner, who was originally from Indiana and was known for his humorous monologues about a fictionalized Hoosier town, appeared on radio and television in the 1940s and 1950s. The photograph above was taken on April 20, 1970, at the Breakers Hotel in Palm Beach, where Shriner was making a personal appearance. Shriner is on the left, the author in the middle, and Herb's wife, Eileen, is on the right. The author left early to drive home to Fort Lauderdale and said good night to the Shriners. The next morning the author read that the couple was killed in a car crash on the way back from Palm Beach. This is the last photograph taken of Herb and his lovely wife. During the early days of the Miami Dolphins, a number of the football games were only telecast on a regional basis, so it was necessary to have entertainment during half-time for the spectators. The author had a contract with the Dolphins to produce half-time shows, and the 1968 photograph below shows (from left to right) George Bergman, the author, television personality Ed McMahon, and local television celebrity Jack Belt.

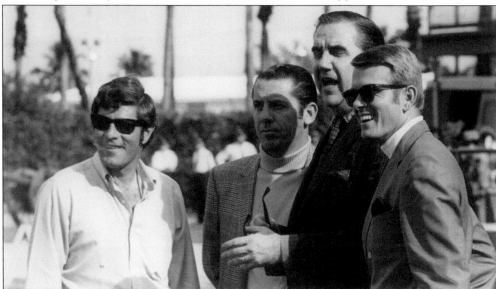

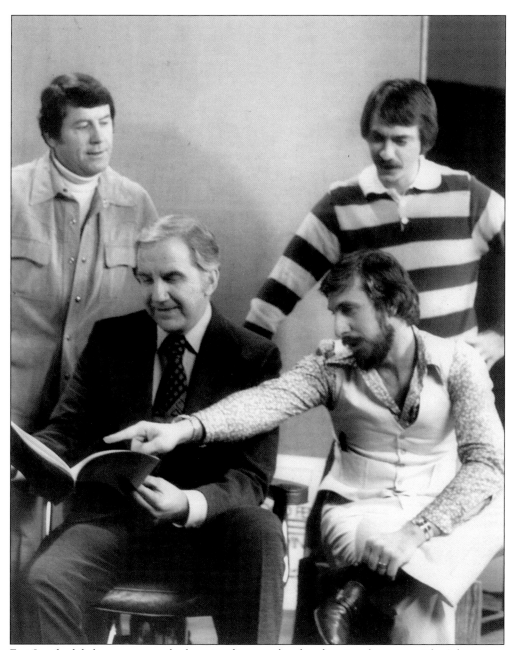

Fort Lauderdale became a popular location for many local and national commercials. Advertising agencies and film companies were attracted because of union rates, low hotel costs, multiple locations, and cooperation by the city to obtain permits. This 1982 photograph shows Ed McMahon reviewing a television script prior to filming. Pictured from left to right are the author, McMahon, advertising creative director Stan Harris, and an unidentified person.

Advertising agencies often use celebrities in commercials to get the attention of viewers who might not otherwise watch. Mamie Van Doren, who Universal Studios hoped would be as popular a blonde sex symbol as Marilyn Monroe and Jayne Mansfield, is seen in the photograph checking in at the airport after filming a commercial in Fort Lauderdale. Van Doren, who was named after President Eisenhower's wife, Mamie, also had a famous relative, Charles Van Doren, who made front-page news by winning $129,000 on a television game show and then admitting that the program was rigged. Mamie Van Doren's visit to Fort Lauderdale in 1964 followed the release of one of her best movie roles in *The Candidate*.

The author met two of the best quarterbacks to ever play professional football at the Jackie Gleason Inverrary Classic when they played in the celebrity pro-am tournament (see page 80). Remaining in contact with both of them, the author offered Johnny Unitas a chance to come to Fort Lauderdale to appear in a television commercial. The 1982 photograph at right was taken on location during a break in the filming showing Unitas (left) with the author. Unitas had an outstanding career, mostly with the Baltimore Colts, and was the National Football League's most valuable player in 1959, 1964, and 1967, leading the Colts to championships in 1958 and 1959. The 1981 photograph below was taken at the American Express building in Plantation, where the author arranged for Joe Namath to make a sales film for his client, American Express. Namath made history by guaranteeing a New York Jets win over the favorite Baltimore Colts in the 1968 Super Bowl played in Miami. Namath and Unitas were involved in one other head-to-head meeting on September 24, 1972, when Unitas threw for 376 yards and three touchdowns, but Namath upstaged Unitas again, throwing 496 yards and six touchdowns in a 44-34 Jets victory.

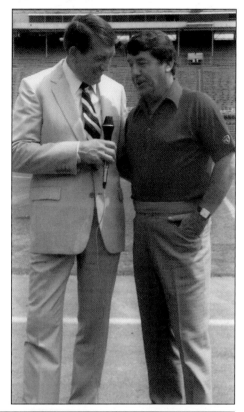

Burt Reynolds, a Florida resident for many years and a Palm Beach High School graduate, as well as a star halfback on the Florida State University football team, was often visible in Fort Lauderdale. Reynolds, shown in this 1996 photograph with Lisa Scott-Founds, the president and chief executive officer of Winterfest, used Fort Lauderdale for the location of a couple of his films, including *Strip Tease*, which was produced in 1996. Reynolds is one of America's most recognizable film and television personalities, with 90 features films and more than 300 television episodes to his credit. Reynolds held the title of the No. 1 box office actor for five consecutive years, from 1978 to 1982, a record no one else has ever achieved. Reynolds was also a partner in a Fort Lauderdale restaurant located in Port Everglades called Burt and Jack's.

In September 2000, socialite and Boca Raton business woman Yvonne Boice headed up a committee to honor new football coach Howard Schnellenberger at Florida Atlantic University. Boice asked the author to put together a tribute to the coach by inviting some of his former players to come to Boca Raton. Pictured above from left to right are Coach Schnellenberger, unidentified, Earl Morrall, the author, Paul Warfield, Roman Gabriel, and Manny Fernandez. Each participant told his personal stories of playing for Schnellenberger. A reception followed, and pictured below from left to right are (first row) former quarterbacks Earl Morrall and Roman Gabriel with former University of Miami All-American Ted Hendricks; (second row) Linda Babs, Sarah Baily, the author, and former Miami Dolphins star receiver Paul Warfield.

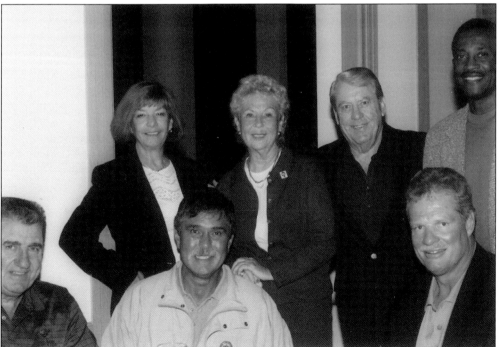

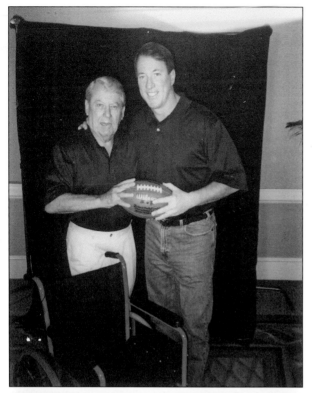

For years, the Miami Dolphins football team had a problem beating the Buffalo Bills, mainly because of former University of Miami star Jim Kelly, who led the Bills to four consecutive Super Bowls from 1990 to 1993, although the Bills lost all four games. Kelly played in the NFL for 11 years and was inducted into the Pro Football Hall of Fame in 2002. But despite all his awards, Kelly (pictured above, right) took time to help the author raise funds for the Wheelchair Foundation in 2003. The image below is an autographed photograph to the author from motion picture star Leslie Nielsen, who visited South Florida in 2005 to participate in a film festival. After moving to Hollywood, California, in 1954 and signing a contract with Paramount Studios, Nielsen appeared in many movies, including *The Poseidon Adventure* in 1972. His early career was mostly as a dramatic actor, but his comedic breakthrough came in the 1980s movies *Airplane* and later the *Naked Gun*.